TURNER AND NATURAL HISTORY: THE FARNLEY PROJECT

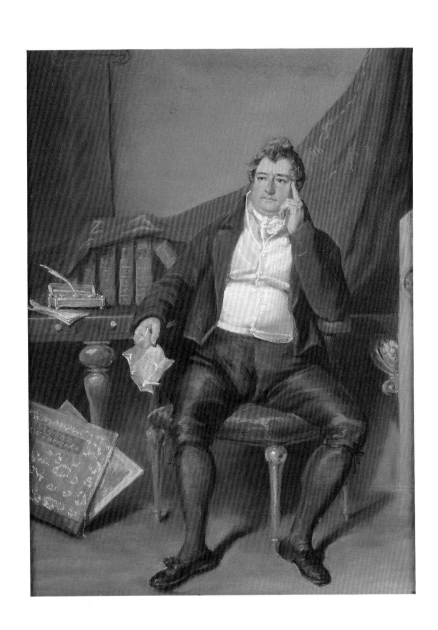

ANNE LYLES

Turner and Natural History

The Farnley Project

THE TATE GALLERY

front cover
J.M.W. Turner, *Heron,* *c.* 1815–20 (cat.no. 34)

back cover
J.M.W. Turner, *Study of a Dead Pheasant and Woodcock,*
Hanging against a Picture Frame, *c.* 1820 (cat.no. 42)

frontispiece
British School, *Portrait of Walter Fawkes (1769–1825),*
c. 1815 (cat.no. 1)

Photographic credits: James Austin, Leeds City Art Galleries,
Tate Gallery Photographic Department

ISBN 1 85437 001 4
Published by order of the Trustees 1988
for the exhibition of 10 October 1988–2 January 1989
Copyright © 1988 The Tate Gallery All rights reserved
Designed and published by Tate Gallery Publications,
Millbank, London SW1P 4RG
Typeset by Gloucester Typesetting Services in 'Monotype' Bulmer 12/16pt
Printed in Great Britain by Westerham Press Ltd on 150gsm Parilux Cream

Contents

Foreword

This exhibition owes its inception to a happy combination of circumstances: in 1985 Leeds City Art Gallery acquired the album of bird drawings made by Turner for his friend and patron, Walter Fawkes of Farnley Hall, Otley, not far from Leeds. This year sees the centenary of the Gallery and it was felt that the bird drawings, newly cleaned and visible as a group for the first time since the album was bound in the second half of the nineteenth century, would provide a suitable celebration of this event. The exhibition was generously sponsored by Messrs Hepworth & Chadwick, solicitors in Leeds. It seemed appropriate that such an important group of works should also be put on display in the Clore Gallery, as one of its series of thematic exhibitions.

We are extremely grateful for this opportunity to show the bird drawings in the context of Turner's work as a bird draughtsman in general, and hope that by bringing together a representative number of examples from several sources both within and outside the Turner Bequest the exhibition will shed new light on his achievement. David Hill has written an authoritative book on the subject, *Turner's Birds*, and Anne Lyles, Assistant Keeper in the Turner Collection at the Clore Gallery, has chosen the supplementary material. She has also written a catalogue incorporating new findings in this hitherto little researched aspect of the artist's work.

In this task she has been greatly helped by numerous people, to whom we extend our hearty thanks. In particular, Nicholas and Susannah Horton-Fawkes have been unfailingly kind and accommodating; David Hill has shared his detailed knowledge of the subject; and the staff of the Zoology Library of the Natural History Museum have assisted with much advice and information. We also thank Lindsay Stainton and the staff of the British Museum Print Room, Terry Friedman, Alex Robertson and Corinne Miller at Leeds, and the staff of the Print Room of the Ashmolean Museum, Oxford. Anne Lyles has also received invaluable help from David Elliston Allen, James Blair, Timothy Clifford, Arturo Cuéllar, Peter Davis, Bill Drummond, Pat Dyer, Lady Elton, Jane Farington, Geoffrey Hancock, Craig Hartley, Kathryn Moore Heleniak, Christine Jackson, Evelyn Joll, Tania Jones, Edward King, Martin Krause, Anthony Lowther-Pinkerton, Rupert Maas, Hugh MacAndrew, Edward Mayer, Jeremy Pearson, Bruce Robertson, Robin Roger, Mary Sanderson, John Sheeran, Gregory Smith, Christopher Swan, Karen Taylor, Sue Valentine, Clive Wainwright, David Wardlaw, Peter Whitehead and Edward Yardley. To all these people, and above all to those who have so generously lent to the exhibition, we are greatly indebted.

Nicholas Serota
Director

Introduction

On 23 January 1852 John Ruskin wrote to his father from Venice. He was anxious to add to his collection of watercolours by Turner, who had died only about a month before, and for the benefit of his father listed, in order of 'desirability of purchase', the four categories of drawings he most coveted. In class one, comprising just a handful of watercolours by Turner which he defined as 'those which I would give *any* price for it if I *had* it to give', Ruskin included 'Fawkes's 4 studies of Birds: Ringdove, Kingfisher, Heron, Peacock' (see cat.nos. 23, 33, 34, 28 and ills. 30 and 10).[1]

These birds had been painted by Turner, together with sixteen others (cat.nos. 16–22, 24–27, 29–32 and 35), for a five-volume album, the *Ornithological Collection* (see cat.no.15), compiled earlier in the century for the library at Farnley Hall, the Yorkshire home of the artist's patron, Walter Fawkes. It was only the previous year that Ruskin had first visited Farnley and examined the volumes which, as well as watercolours by Turner and other artists, contained wood-engravings by Thomas Bewick and specimens of birds' feathers collected by members of the family. With the exception of two watercolours by Turner which had probably already been removed[2] (cat.nos. 23 and 31), in 1851 the *Ornithological Collection* still remained intact. Ruskin, however, was 'of opinion that the fact of rubbing against the feathers was injurious to these works of art, which were very badly mounted'.[3] On his advice, the remaining eighteen watercolours by Turner were removed from the volumes, and set aside 'in a book'; together with the other two they were mounted up, 'many years later',[4] in a separate album which was to become known as the 'Book of Birds'. In this form they remained for about a century in the library at Farnley Hall, until they were sold in 1984–85, and acquired by Leeds City Art Gallery.

Ruskin was thus never given the opportunity of acquiring the four watercolours by Turner from the *Ornithological Collection* he had so longed to purchase in 1852. There were, however, a number of other bird studies by the artist, chiefly of dead game, which had not been made for the album and which Ruskin also believed had been painted at Farnley: 'Nowhere but at Farnley. He could only do them joyfully there!'[5] Many of these were acquired by Ruskin for his own collection over the ensuing years (cat.nos.38, ?39, 40, 60, 65–66), probably directly from members of the Fawkes family for whom, it seems, they had been painted.

Indeed, Ruskin was in a position to familiarise himself with the entire range of Turner as a bird draughtsman. In the second half of the nineteenth century he was responsible for making selections of drawings for public exhibition from the Turner Bequest – the contents of the artist's studio which had been acquired for the nation by a settlement drawn up five years after Turner's death in 1851. As well as draw-

ings of birds in sketchbooks (cat.nos. 48–50) the Bequest also included a number of bird and fish studies in watercolour (cat.nos. 42–45, 51–52), and Ruskin would often show some of these in the exhibitions he chose for Marlborough House in 1857–58 and, thereafter, at the National Gallery. In the accompanying catalogues which he also wrote, the critic would frequently compare them with the bird studies by Turner still remaining at Farnley, speaking of them together in terms of unqualified praise: 'These bird drawings of Turner', he wrote, 'were more utterly inimitable than . . . anything else he had done';[6] 'the artists of the world may be challenged to approach them'.[7]

Ruskin's appreciation of Turner's bird drawings marks the apogee of their critical acclaim. Soon after his death in 1900, however, they dropped dramatically in the estimation of writers on Turner and his art. The bird studies made for the *Ornithological Collection* received short shrift from Walter Armstrong and A. J. Finberg[8] who, embarassed by their assocation with a family scrapbook, dismissed them as belonging to those labours of a 'less dignified kind' which the artist undertook at Farnley, 'unworthy of the genius and skill that were lavished upon them'; only grudgingly was Finberg prepared to admit their quality.

Ruskin, it is true, had not even mentioned the *Ornithological Collection*, but chose rather to evaluate the bird drawings Turner made for this album as independent works of art. A modern critic should seek both to assess them as Ruskin did, on their own merits, and also within the context for which they were made, for the *Ornithological Collection* dictated their size, format and much of their character. Indeed, for a modern audience, to see these drawings in their context rather enhances their appeal; for in their intimacy and spontaneity, and as the product of a unique relationship between Turner and his patron, they help to reveal the private face of the artist which is otherwise more difficult to discern.[9] Moreover, a closer look at the genesis of the *Ornithological Collection* helps throw new light on the interests and enthusiasms of Turner's most important patron.

Walter Fawkes and Natural History

A little-known pastel portrait of Walter Ramsden Hawksworth Fawkes (1769–1825) (frontispiece, and cat.no. 1) shows him seated near a table, against which leans a half-opened portfolio of drawings inscribed 'J. W. Turner R. A.'. It is as a patron of Turner that Fawkes is today chiefly remembered. The story of the warm friendship between the two men, the interests they shared in common, and the very happy and fruitful visits Turner made to Farnley Hall between 1808 and 1824 is now familiar[10] and needs no repetition. What should be stressed, however, is how the character of Turner's work for Fawkes changed as the friendship between the two men matured, and as the artist gradually became regarded as one of the family. In the early years of the century, as John Gage so well explains,[11] Fawkes had acquired works by Turner either from exhibition or by commission, along normal professional lines; now, from about 1815, the work Turner undertook for his patron became 'more intimate and autobiographical'.

It was about this time that Turner began a series of free bodycolour 'sketches' of the house, grounds and neighbourhood at Farnley which Fawkes referred to as 'the Wharfedales'[12] (cat.nos. 3–10, ill. 1). He also contributed a number of watercolour illustrations for a variety of family albums on subjects in which Fawkes himself took a personal interest. The *Fairfaxiana*, for example, is a series of seventeen watercolours painted for Fawkes mainly relating to the period of the English Civil War. Most of these watercolours, it has been suggested by David Hill,[13] would originally have been bound up in an album containing the family's collection of historical documents and housed – together with the other relics of the period Fawkes owned[14] – in the museum of the Civil War period he was then creating in the old wing at Farnley (see cat.no. 6). Four of these watercolours by Turner, however, seem rather

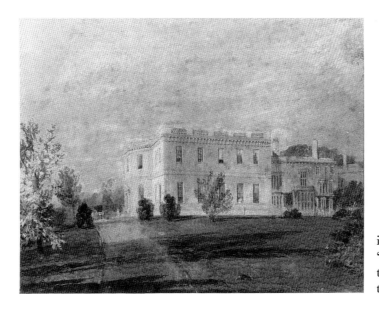

ill. 1 J. M. W. Turner, 'View of Farnley Hall: the "New House" from the East', *c.* 1816 (cat.no. 3)

to have been designed specifically as frontispieces for what has been described as 'a History of England in pictures, in several volumes', and for which the family cut up a number of valuable books from the library to provide illustrations.[15] Just as the *Fairfaxiana* project undoubtedly stems from Fawkes's interest in history[16] and, in the broadest sense, can be seen to reflect his political position on the subject of Parliamentary reform,[17] so too the *Ornithological Collection* should be viewed within the context of another of his amateur enthusiasms, that of natural history.

The library at Farnley (ill. 2) was mostly assembled by Fawkes himself, and has been described as reflecting 'ideally the tastes of a country gentleman of liberal and cultivated outlook in the first quarter of the nineteenth century'.[18] Amongst the many books he owned on history, philosophy, theology, poetry, travel and the classics, were a wealth of publications on natural history. Shelved together with volumes devoted specifically to plants, insects, shells and especially birds, were also more general works such as Pliny's *Natural History*, Gilbert White's *Natural History and Antiquities of Selborne*, Linnaeus's *Systema Naturae* in an English edition of fourteen volumes dated 1816, and an early nineteenth-century French publication of 'Natural History Plates' in eighteen volumes. Two years before his death in 1825, another publication in four volumes was added to the shelves, a *Synopsis of Natural History*, this one written by Fawkes himself. The title-page bears the following dedication: 'To his son, Hawksworth Fawkes, Esq., of Hawksworth, this Synopsis of Natural History is inscribed by his Affectionate father Walter Fawkes, Esq., of Farnley Hall. 1823.'

The *Synopsis* is a broad survey of the animal kingdom ranging from mammals (volume I) and birds (volumes II and III) to amphibia, fish, insects and shells (volume IV). Each individual species is placed under a principal genus, assigned a class and order number, and then given a brief description. In fact the *Synopsis* seems essentially to have been conceived as a picture book of natural history, since each species is illustrated with an individual watercolour by Samuel Howitt (1756–1822), a

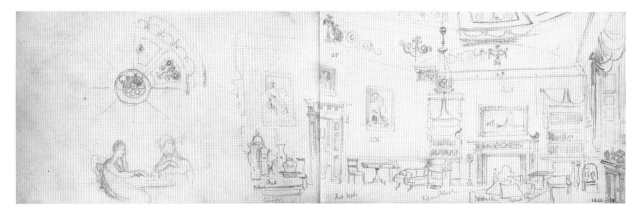

ill. 2 J.M.W.Turner, 'Interior of the Library, Farnley Hall', *c.*1818 (cat.no.14)

painter who specialised in sporting art as well as subjects of natural history. The birds are classified according to the principles adopted by Linnaeus in *Systema Naturae*, and which are explained by Ruskin in *The Eagle's Nest*: 'Linnaeus, for all his classes except the Stilt-Walkers, used the name of the particular birds which were the best types of their class; he called the snatchers, 'hawks' (Accipitres), the swimmers, geese (Anseres), the scratchers, fowls (Gallinae).'[19] In the *Synopsis* each new class of birds provides the occasion for a particularly elaborate frontispiece by Howitt (ill. 3), and these recur at regular intervals throughout all four volumes.

Indeed, it seems likely that most of the *Synopsis* is broadly based on Linnaeus's key work, the *Systema Naturae* which, first published in 1735, was for many years the 'bible of natural history'[20] and a copy of which – as it has been seen – Fawkes himself owned. However at occasional intervals in the *Synopsis* there appears a sub-category as dear to the heart of Fawkes as to many an English country squire in this period, 'British Sport'. Thus just as volume III includes under this category a study of dead grouse by Howitt, so does volume IV boast a study of recently-caught 'Fresh Water Fish' (ill. 4). The *Synopsis* may be serious, but can hardly be described as scientific. Rather, it is the achievement of an enthusiastic amateur.

Nor does this interest in natural history appear to have been restricted to the purely literary sphere. Fawkes is reputed, for example, to have stocked the park at Caley Hall with zebras and with a species of deer from India (see under cat.no.8). Moreover, in the 1816 'Companion to the London Museum and Pantherion . . . [at] The Egyptian Temple, Piccadilly', 'Walter Fawkes Esq' of 'Farnley Hall' is listed amongst the 'Names of the Ladies and Gentlemen who have presented Curiosities to the Museum'.[21] This remarkable museum of natural history[22] housed the vast collections of the Liverpool jeweller-silversmith turned naturalist William Bullock (fl.1795–1840), brother of the famous cabinet-maker George Bullock. Its origins can be traced back to the mid-1790s when William Bullock first opened a cabinet of natural curiosities in Sheffield[23] (and when it is possible that Fawkes and Bullock may first have come into contact). By 1801 the museum had been transferred to Bullock's home town, Liverpool, and then by 1809 to London, where it opened at 22 Piccadilly; it was not until 1812 that it was moved to larger premises at the purpose-built Egyptian Hall. Here the vast collections of 'preserved specimens in natural history', consisting of 'about 15,000 quadrupeds, birds, reptiles, fishes, insects, corals etc'[24] were arranged according to the Linnaean system and, where possible, set up in naturalistic poses and displayed amidst a suggestion of their habitat.

Whilst there is no guarantee that it was stuffed specimens rather than works of art that Fawkes donated to the museum, the Bullock connection is nevertheless important for the light it sheds on the *Synopsis*. For between 1809 and 1813, and probably in other years as well, the *Companion* guides to the London Museum written by Bullock himself were illustrated with numerous etchings by Samuel Howitt.[25] It seems more than likely that it was through the agency of Bullock that Howitt's com-

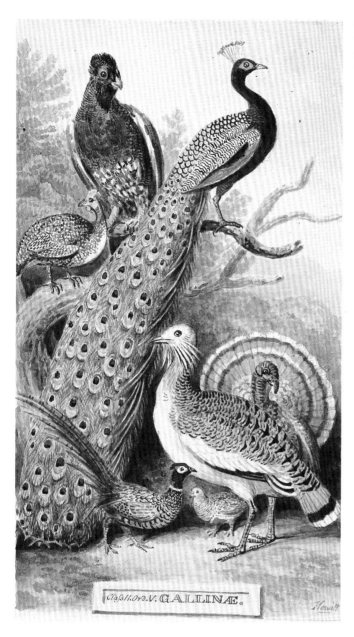

ill.3 S.Howitt, 'Gallinae', *c.*1815–20, watercolour, 196 × 114 mm, frontispiece in volume III of *Synopsis of Natural History* by Walter Fawkes (Private Collection)

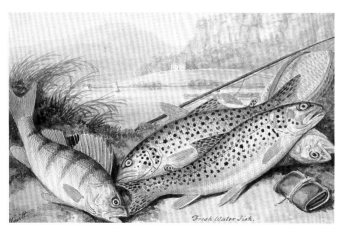

ill.4 S.Howitt, 'Fresh Water Fish', *c.*1815–20, watercolour, 101 × 162 mm, illustration to 'British Sport' in volume IV of *Synopsis of Natural History* by Walter Fawkes (Private Collection)

mission to illustrate the *Synopsis* was procured. Furthermore, since some of the bird drawings made by Howitt for Fawkes are inscribed 'Mr Bullo[ck]',[26] it is probably safe to assume that many of the 350 watercolours in the *Synopsis* – as well as the thirteen watercolours of birds Howitt contributed to the *Ornithological Collection* – were made from specimens in Bullock's Museum.[27]

Two out of four of the volumes which make up the *Synopsis* were devoted to birds. In Fawkes's library, publications on ornithology outnumbered those on other branches of natural history by about the same proportion. As a boy, Fawkes had been given a copy of Willughby and Ray's pioneering *Ornithology*, 1678, by his father (see under cat.no. 56).[28] In later years he acquired a wide range of ornithological books, many of them published in his own lifetime, on German, American, French and British species.[29] By 1822, three years before his death, Fawkes was sufficiently well abreast of the contemporary literature (particularly foreign publications) that he was able to keep an ornithologist as well-read as Thomas Bewick up-to-date. For in a recently-discovered letter from Bewick to Fawkes, dated 1822 and published here for the first time (ill. 5), Bewick writes of how Fawkes has 'whetted [his] curiosity exceedingly' about a number of ornithological works, including the 'German work . . . on European Birds'[30] which he now 'long[s] for a sight of' (see Appendix I, no. 9).

ill. 5 Letter from Thomas Bewick to Walter Fawkes, 1822 (Appendix I, no. 9)

Bewick was writing to Fawkes to inform him of the birds he had included in his recent supplement to the *History of British Birds*;[31] he encloses a list of these, adding that Fawkes will know by their names 'how to place them in the valuable works of Mr. Pennant & Dr. Latham'[32] – Turner's patron was clearly well versed in the principles of bird classification. Fawkes already owned copies of the *History of British Birds* in two editions,[33] and these we now know were almost certainly sent directly by Bewick. For other letters between the latter and members of the Fawkes family – chiefly Francis Hawksworth, the eldest of Walter Fawkes's three brothers[34] – reveal that various copies of 'Birds & beasts' were ordered direct from Newcastle (see Appendix I, nos. 1, 2 and 8) and usually paid for by Fawkes himself (see nos. 2 and 8). One of these copies, probably that ordered in 1811 (Appendix I, no. 8), was destined to be cut up for another of Fawkes's grangerised family albums, the *Ornithological Collection*.

The Ornithological Collection

Volume one of the *Ornithological Collection* opens with six small pencil drawings by Bewick – of gulls, grebes, ducks and a man fishing – which are entitled 'Specimens of Mr. Bewick's Drawings, from which his plates were cut'. It was probably some of these to which Francis Hawksworth was referring in his letter to Bewick dated 3 January 1811 when he wrote that he was hoping 'to receive a couple of your small sketches for which . . . Mr. Fawkes will be obliged' (Appendix I, no. 8). In the same letter Hawksworth enclosed payment for the 'Two sets of Birds & beasts sent to Mr. Fawkes'. The 'set' or 'sets of Birds'[35] can probably be identified with the 1809 edition[36] of Bewick's *History of British Birds* which was cut up to provide illustrations for the *Ornithological Collection*.

It was the wood-engravings of birds which were required for the album; most of the engraved vignettes and accompanying text were discarded. However, the 'Explanation of the Technical Terms' Bewick had used to explain the different parts of a bird and its plumage was retained and included at the beginning of the *Ornithological Collection*; similarly Bewick's contents lists were pasted down at the back of the volumes to serve as an index (ill. 6). The *History of British Birds*, indeed, was the *raison d'etre* of the *Ornithological Collection*, the purpose of which was to try to assemble examples of the plumage for as many species as possible listed in Bewick's publication. Only where the feathers proved too difficult to collect would a species be omitted from the album, such as the four eagles and the osprey which had opened Bewick's 'Land Birds' and which are absent from the contents list to the first volume (ill. 6, and see Appendix I, no. 3). Volume one covers the first half of Bewick's 'Land

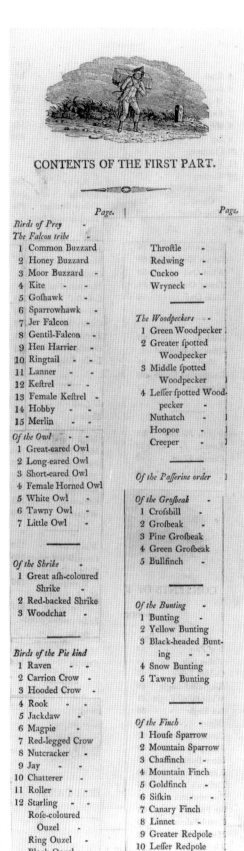

CONTENTS OF THE FIRST PART.

ill. 6 Contents List from Bewick's *History of British Birds* (Vol. I), pasted down at back of volume I of the *Ornithological Collection* to serve as an index

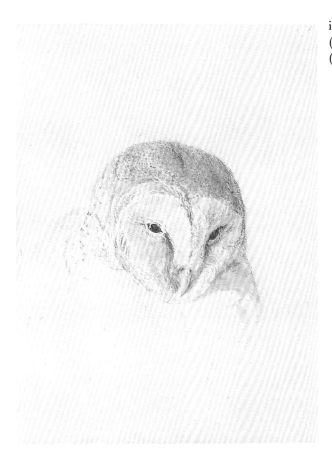

ill. 9 J. M. W. Turner, 'Barn Owl',
('Head of White Owl'), *c.*1815–20
(cat.no.17)

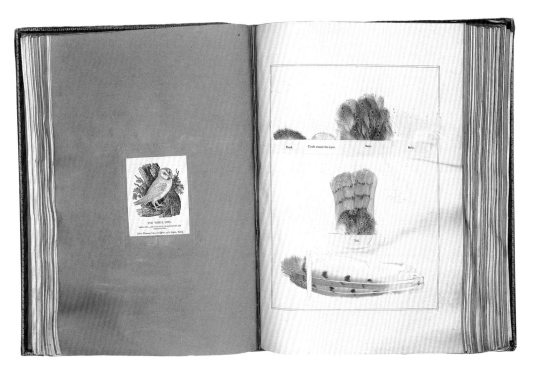

ill. 7 *Ornithological Collection*, volume I, opened at pages showing
wood-engraving of 'The White Owl' by Thomas Bewick and the bird's
plumage, *c.*1820–25, 1,014 × 700 mm approx. (Private Collection)

ill. 10 J. M. W. Turner,
'Peacock', *c.* 1815–20
(cat. no. 28)

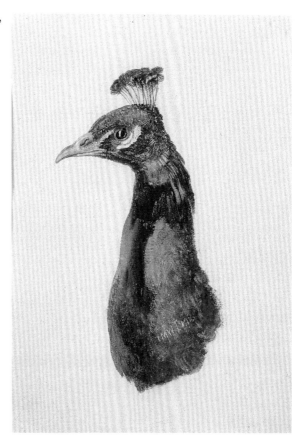

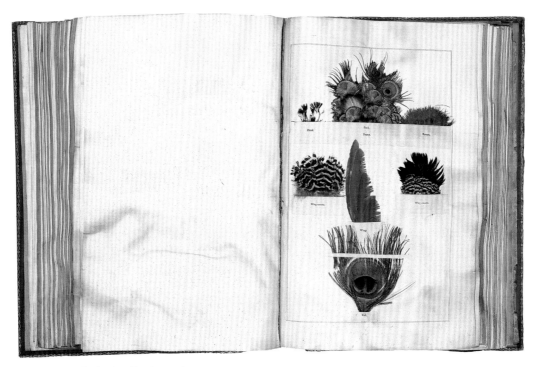

ill. 8 *Ornithological Collection*, volume II, opened at
page showing plumage of the peacock, *c.* 1820–25,
1,014 × 700 mm approx. (cat. no. 15)

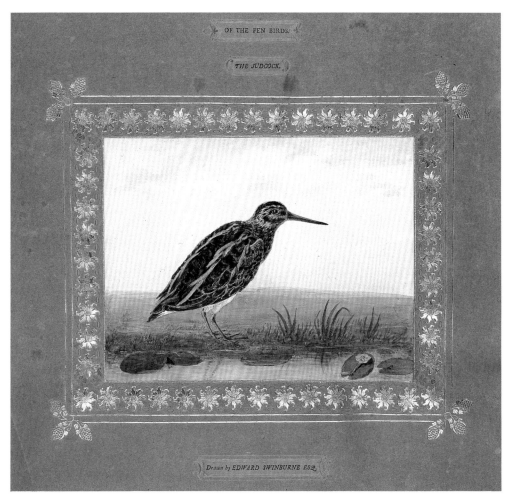

ill. 12 Edward Swinburne, 'Judcock', frontispiece to
'Of the Fen Birds', *c.*1815–20, watercolour, 150 × 187 mm
(*Ornithological Collection*, volume III)

Birds' from 'the Falcon tribe' to 'Of the Finch', while volume two spans the second half from 'Of the Lark' to 'Of the Plover'. The remaining three volumes cover most of the 'Water Birds'.

Each of the five morocco-bound volumes which make up the *Ornithological Collection* contains about one hundred alternately interleaved brown and white pages.[37] The brown pages were generally reserved for the illustrations, the white for the feathers. A wood-engraving by Bewick, trimmed to include the title of the bird, would be pasted down on the *verso* of a brown page; opposite this on a white page would be examples of its plumage, enclosed within a double red wash-line border, and named according to which part of the bird they came from (ill. 7). Over two hundred and fifty species follow each other according to this arrangement (although not all of them have feathers). Of these, about a quarter also boasted a watercolour illustration, generally attached to the other side (the *recto*) of the brown page with the engraving. One of these, for example, was the peacock; when Turner's water-

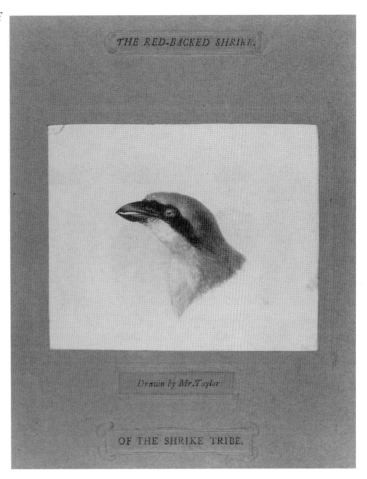

ill. 11 Mr Taylor, 'Head of a Red-backed Shrike', frontispiece to 'Of the Shrike Tribe', *c*.1815–20, watercolour, 85 × 105 mm (*Ornithological Collection*, volume I)

colour illustrating that bird was removed, the whole page was cut out, leaving a blank white page opposite the examples of the bird's plumage (ill. 8, and cat.no. 15).

Many of the watercolours, however, rather than appearing in the position where the bird was listed by Bewick, would rather be pasted down earlier, at the beginning of the genus to which it belonged and where they would serve as a frontispiece. This was the case, for example, with Turner's watercolour of the 'Barn Owl' ('Head of a White Owl', ill. 9) which was selected as the frontispiece to the genus 'Of the Owl'; thus, although the page with Turner's watercolour was subsequently removed, the double-page spread of wood-engraving and plumage has remained intact in the album (ill. 7). When in such a position, Turner's watercolours would have looked very similar to those still remaining as frontispieces in the album: either they would have been surrounded by a plain embossed border, resembling that round Mr Taylor's watercolour of a 'Head of a Red-backed Shrike' (ill.11); or, as was clearly the case for Turner's watercolours of the 'Moorhawk' and 'Robin' (see cat.nos. 16 and 22), introducing 'Of the Falcon tribe' and 'Of the Warblers' respectively, they were surrounded by an elaborate gold border similar to that framing Edward Swinburne's 'Judcock' (ill. 12).

Half of the twenty watercolours Turner contributed to the *Ornithological Collection* appear to have served as frontispieces in this way (cat.nos. 16–18, 20, ?21, 22–23, ?24, 34–35); which represents, in turn, just over half of all the frontispieces in the volumes (see Appendix II). Sometimes, as was the case for Turner's 'Green Woodpecker' (ill. 13), a watercolour might both act as a frontispiece and happen to be the first of the birds listed by Bewick under that genus. In this particular example, Turner's watercolour was selected for this position in preference to Samuel Howitt's watercolour of the same bird (ill. 14), which was accordingly displaced to a position following the bird's plumage.[38] The ten watercolours by Turner which served as frontispieces do not seem to have been specifically designed for this function as, say, had the four illustrations he contributed to *Fairfaxiana* discussed above. However, once the idea had arisen to use some of the watercolours painted for the *Ornithological Collection* in this way, wherever possible Turner's were placed in a position of prominence.[39]

Just as an introductory watercolour would open a new genus in the *Ornithological Collection*, so too were illustrations of birds' eggs included to close one, painted in bodycolour on vellum 'from the Portland Museum by William Lewin' (ill. 15). As well as a large collection of birds' eggs and cards of birds' eggs, in the mid to late eighteenth century the Duchess of Portland had assembled a vast collection of items of natural history and the fine arts which has been described as 'certainly the largest in Britain, quite possibly the largest in Europe'.[40] The collections were housed both in her Buckinghamshire mansion at Bulstrode (where she also had a botanic garden and menagerie) and at her London house at Privy Garden, Whitehall where, in 1786, they were sold by auction over a period lasting thirty-eight days. The frontispiece to the sale catalogue[41] (ill. 16) gives an idea of the range of these collections – which included shells, corals, insects, stuffed birds, snuff-boxes, and items of porcelain and china, as well as the famous Portland Vase conspicuous in this illustration – and also splendidly evokes the flavour of a typical eighteenth-century 'cabinet of natural curiosities'.

William Lewin (1730–1795) was one of the many eminent naturalists who were granted access to the Duchess's museum. The fifty-two plates of birds' eggs in the first edition of *The Birds of Great Britain* (1789–1794) by Lewin were copied from specimens in the Portland Museum and individually hand-painted in bodycolour (along with the 271 species of birds themselves) for each of the sixty subscribers. The plates of eggs in the *Ornithological Collection*, however, are more carefully painted than most of those in the first edition of *The Birds of Great Britain*;[42] either they were cut up from one of the four special copies painted on vellum which are known to exist;[43] or they may have been taken from one of the extremely rare volumes by Lewin, devoted exclusively to birds' eggs, which he painted shortly before the contents of the Portland Museum were sold.[44] In either case, the work was not without a certain local significance. For most of the eggs in the Portland Museum had been

ill.13 J.M.W. Turner,
'Green Woodpecker', *c.*1815–20
(cat.no.20)

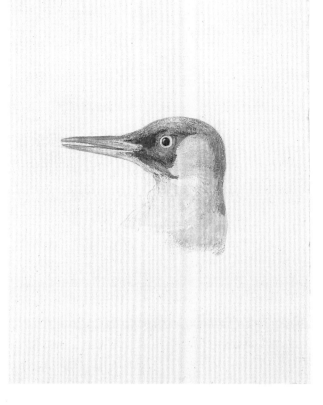

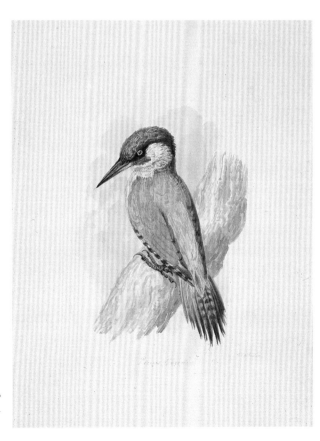

ill.14 S.Howitt, 'Green Woodpecker',
*c.*1815–20, watercolour, 246 × 189 mm
(*Ornithological Collection*, volume I)

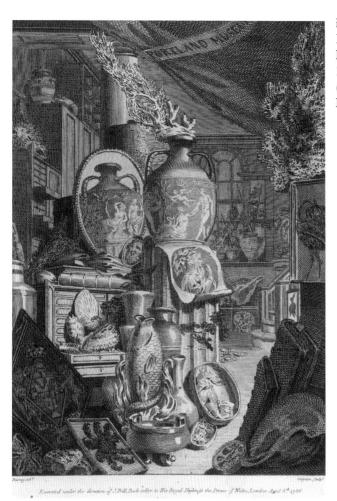

ill. 16 C. Grignion after Burney, 'The Portland Museum', 1786, etching, 189 × 135 mm (image) (British Museum, Natural History)

'collected in Yorkshire' in the late eighteenth century by the Halifax naturalist and ornithological writer, James Bolton (d. 1799).[45]

For whom was such a lavish and elaborate album as the *Ornithological Collection* intended? In 1851, only a few months before his death, Turner wrote to Hawksworth Fawkes (Walter Fawkes's eldest son) recalling his involvement in the project, although his memory was by this date rather hazy: 'The Birds I think were pasted or fixed in Major Fawkes Book of Ornithology rather of a large size to illustrate his wishes'.[46] As David Hill has argued, it is difficult to imagine a young boy of seven compiling such a complicated album as this himself,[47] even if Turner had remembered correctly that the young boy showed an interest in the project. Later in the century, Edith Mary Fawkes, the wife of Walter Fawkes's grandson, Ayscough Fawkes, remembered that the album had been compiled 'by a brother of Walter Fawkes's'.[48] It is, indeed, now clear that whilst Fawkes certainly paid for the project,[49] and probably supervised it as well, it was his brother Francis Hawksworth who collected the feathers. This was a long and demanding task which had started much earlier in the century, and in which Hawksworth was assisted by his brother-

ill. 15 W. Lewin, 'Eggs of the Falcon Tribe', *c.*1780–85, bodycolour on vellum (*Ornithological Collection*, volume I)

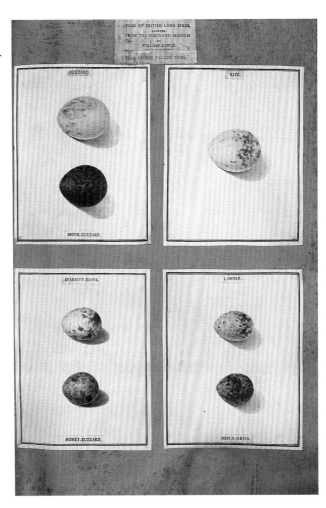

in-law Charles Brandling of Gosforth House, Northumberland and Middleton, Yorkshire.[50]

On 23 December 1810 Francis Hawksworth wrote to Thomas Bewick that 'I have been a long Time employed in collecting the Feathers of every bird described by you in your Two books of Land and water birds. I am in possession of a great many' (Appendix I, no. 5). Only a few months before he had also written to his brother Ayscough[51] explaining that, as far as the land birds were concerned, he was now only lacking feathers for the eagles, the roller, the nutcracker and ten other birds which he listed (Appendix I, no. 3). He then asked Ayscough if, when staying with their brother-in-law Charles Brandling in Gosforth, he could call on Bewick in Newcastle and enquire 'in *what county* or in what *particular* places or haunts in Yorkshire' he might find specimens of these birds. Hawksworth adds that he wishes Charles would 'write his Somersetsᵉ friend a line' to say that it is '*only*' the '*Great Ashcoloured Shrike*' he is having difficulty finding; the 'red backed Shrike is common at Farnley' (see ill. 11).[52] When specimens could not be found locally, Hawksworth was clearly prepared to look further afield.

However, as has been argued elsewhere,[53] help from local enthusiasts would not have been difficult to find. For example George Walker (1781–1856) and Charles Waterton (1782–1865), both visitors at Farnley,[54] were keen amateur ornithologists. Walker, who painted a sequence of sporting subjects onto the panels in the oak drawing-room in the old wing at Farnley (see under cat.nos. 6 and 31), had an aviary at Killingbeck Hall in Leeds.[55] The eccentric Waterton, meanwhile – who is today as well remembered for having climbed to the top of the lightning conductor of St Peter's in Rome as for his novel methods as a taxidermist or for his entertaining publication, *Wanderings in South America*, 1825 – created a huge bird sanctuary at Walton Hall near Wakefield, enclosed within a nine-foot high wall.[56] In fact, many of the specimens (especially the land birds) would probably have been found at Farnley itself, often victims of the regular shooting parties there which Turner himself so enjoyed (cat.no. 10). It was on one of these expeditions, for example, that the artist shot a cuckoo (see cat.no. 19), and on another occasion a grouse from which he painted the watercolour in the *Ornithological Collection* (cat.no. 31).

What cannot be doubted, however, is the sheer effort applied to the arduous task of collecting the feathers by Francis Hawksworth himself. He proved remarkably thorough and persevering when trying to identify a difficult species. Four letters have survived, between Brandling, Bewick and Hawksworth, and dated between 22 and 24 December 1810, which appear to relate to the identification of a single specimen shot by Brandling's keeper on Gosforth lake (Appendix I, nos. 4–7). On 22 December, Brandling sends the specimen to Bewick for identification, with a note saying that he himself suspects it to be some sort of coot or a lough diver (Appendix I, no. 4). The same day Bewick pronounces it to be a hen teal. Francis Hawksworth is not satisfied with the answer and, being 'anxious not to insert any feathers in my book without knowing *exactly what* species it is', writes back to Bewick suggesting the alternative identification of a red-headed smew or, as his brother-in-law had thought, the lough diver (Appendix I, no. 5). Bewick drafts a reply, probably the following day, in which he writes that the specimen cannot belong to the genus Mergus but must rather be the female golden eye (Appendix I, no. 6). Hawksworth in the meantime writes another letter to Bewick, dated 24 December (which appears to have crossed with Bewick's reply), this time suggesting the specimen might be the Morillon duck (Appendix I, no. 7).

In the end it was the 'Water Birds' which proved to be the stumbling-block to the comprehensiveness of the *Ornithological Collection*. Perhaps Hawksworth had failed to take into account what Bewick himself had suffered in compiling the second half of the *History of British Birds*, 'the difficulties the sportsman meets with in coming at many of the shy inhabitants of the ocean, and of the pathless misty marsh.'[57] It was surely for this reason that the second third of the 'Water Birds' listed by Bewick, ranging from 'Of the Phalarope' to 'Of the Mergus' was simply omitted from the *Ornithological Collection*, abandoned when the feathers proved too difficult to obtain.

That such a volume was originally envisaged there seems little doubt. Indeed, two recently-discovered bird drawings by Turner, of the smew and the red-breasted merganser (cat.nos. 36–37), as well as four watercolours by Howitt,[58] were almost certainly intended for this volume.

The missing volume would have been bound up as number four, since volume three had covered the first third of Bewick's 'Water Birds' from the 'Sanderling' to 'Of the Coot'. It was now decided – possibly because the *Ornithological Collection* had originally been planned in five volumes or simply in a spirit of family rivalry – to cover the remaining third of Bewick's 'Water Birds' (ranging from 'Of the Anas' to 'Of the Pelican') in two duplicate volumes. It is perhaps significant that these two volumes, numbers four and five, appear to have been assembled some years later that the previous three.[59] For by now much of the momentum seems to have gone out of the project. Many of the feathers still could not be collected, considerably fewer watercolours were included (see Appendix II) and the elaborate system adopted in the previous three volumes began to break down.[60]

Of the fifty-five watercolours of birds included in the *Ornithological Collection*, Turner's contribution of twenty was easily the largest (see Appendix II). There then followed Samuel Howitt's quota of thirteen. The remaining twelve illustrations were almost all by family and friends, patrons and local gentry who must have made

ill. 17 J. M. W. Turner, 'Woodcock Shooting on the Chiver [Chevin]', 1813, watercolour, 280 × 400 mm (London, Wallace Collection)

up a lively and fairly close-knit social circle at Farnley. For example, six water-colours (ills. 12 and 19) were painted for the album by Edward Swinburne (1765–1847), the brother (*not* the son as is often thought) of Turner's patron, Sir John Swinburne of Capheaton, Northumberland;[61] indeed it was probably Edward himself rather than his brother who purchased watercolours by Turner of Swiss and German subjects in the first two decades of the nineteenth century.[62] A further four watercolours (see, for example, ill. 23) were made for the *Ornithological Collection* by John Ibbetson (1789–1869) was lived locally at Denton Park, Otley, the brother of the fourth baronet, Sir Charles Ibbetson, and who many years later was to succeed to the family title as the sixth baronet.[63] Both Ibbetson and Swinburne were represented in the exhibition held by Walter Fawkes at his London house at Grosvenor Place in 1819; indeed Turner listed their names on the cover of the accompanying catalogue which he painted.[64] A further contributor, and another of Turner's patrons, was Sir William Pilkington[65] (d. 1850) of Stanley Chevet, Wakefield, who is known to have visited Farnley for the woodcock shooting (ill. 17, and see cat.no. 13), and who was also friendly with Edward Swinburne – the two men are recorded as attending the same supper party as Joseph Farington in London in June 1804.[66] He painted a dead swallow (ill. 24) for the *Ornithological Collection*.

A further six watercolours were contributed by lady amateurs, two of whom can be identified as family: Lady Armytage, who painted three (see ill. 20), was the daughter of Oldfield Bowles of North Aston, and had moved to Kirklees Hall in Yorkshire on her marriage to the fourth baronet, through whom she became related to the Fawkes family;[67] and Frances Fawkes, one of Walter Fawkes's seven daughters,[68] who contributed a 'Head of a Mallard' to the album (she also painted water-colours of flowers from the conservatory at Farnley between 1817 and 1824). Then there were five watercolours painted by three artists who are more difficult to identify: 'Miss I. Middleton' (see ill. 21) and 'Mr Taylor' (see ills. 11 and 26) were probably local;[69] the watercolour by 'Chevalier de Barde' (Appendix II) may well have been purchased. Finally there were two illustrations by unidentified artists, one of which – a pencil drawing of a 'Dead Golden Eye' – appears to be by the same hand as some of the other, similar drawings of birds which have recently turned up and which imply that an album such as the Farnley *Ornithological Collection* was not unique.[70] Whilst the watercolours by Turner, Howitt and the gentlemen amateurs predominate in the first three volumes, it is those of the lady amateurs which are chiefly represented in the final two.

Although the watercolour illustrations by Samuel Howitt are amongst the more plentiful in the volumes, they are nevertheless the least typical. Indeed Howitt was the only professional ornithological draughtsman to have become involved in what was essentially a family project. The thirteen watercolours he contributed can readily be explained as by-products of the commission he had undertaken to illustrate Walter Fawkes's *Synopsis of Natural History* and with which – although it was not

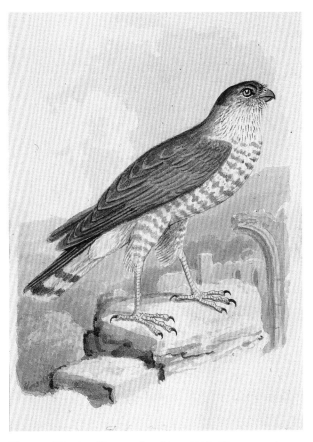

ill. 18 S. Howitt, 'Sparrowhawk', *c*. 1815–20, watercolour, 150 × 107 mm (*Ornithological Collection*, volume I)

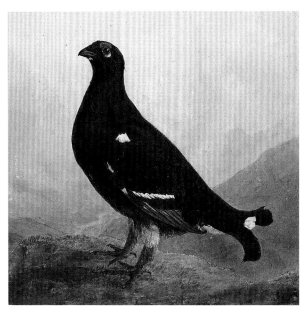

ill. 19 E. Swinburne, 'Blackcock', *c*. 1815–20, watercolour, 234 × 243 mm (*Ornithological Collection*, volume II)

ill. 20 Lady Armytage, 'Head of a Shoveller', *c*. 1815–20, watercolour, 181 × 198 mm (*Ornithological Collection*, volume V)

ill. 21 Miss I. Middleton, 'Head of a Mallard', *c*. 1815–20, watercolour, 110 × 132 mm (*Ornithological Collection*, volume V)

published until 1823 – he is likely to have become involved at a much earlier date. The strength of Howitt's contribution to that publication undoubtedly lay in his vigorous and imaginative frontispieces (ills. 3 and 4). However, most of the water-colours of birds he made for the *Synopsis*, like the thirteen in the *Ornithological Collection*, rely heavily on the somewhat prosaic conventions of bird portraiture employed by eighteenth-century ornithological draughtsmen, dubbed by one writer as the 'Magpie and Stump formula'[71] (see cat.nos. 55 and 56): the bird is always seen whole as well as live, perhaps standing on a rock (ill. 18) or, more often, perching rather stiffly on a branch or tree trunk (ill. 14). Whilst some of the birds in Howitt's drawings were copied from stuffed specimens, as has been seen, others, such as the 'Green Woodpecker' – which is inscribed 'Nature' – would have been made from life;[72] almost invariably his watercolours are inscribed with the Latin, Linnaean names of the bird, for example 'Picus Viridis' and 'Falco Nisus' (ills. 14 and 18). Only one of Howitt's watercolours in the *Ornithological Collection*, the 'Pied Flycatcher', served as a frontispiece, and this was probably only by default.[73]

Most of Howitt's illustrations include some sort of vignette background: at its most summary this simply comprises an area of grey wash (ill. 14); when more elaborate, in the case of the 'Sparrowhawk' (ill. 18), it becomes an imaginary, pic-turesque backdrop. By contrast, the landscape backgrounds included in the bird drawings for the album by Edward Swinburne – a considerable landscape painter in his own right[74] – are more accomplished and considerably more naturalistic. Whilst the 'Judcock' (ill. 12), for example, is seen against a sensitively painted stretch of open fenland, the 'Blackcock' (ill. 19) is shown in a rugged and mountainous terrain, worthy in its atmospheric qualities of the breezy landscapes of the watercolour painter, David Cox (1783–1859). It is interesting to observe that Turner, the only professional landscape artist to paint watercolours for the *Ornithological Collection*, never once included a scenic background in any of the twenty bird drawings he contributed.

Turner's involvement in the project can be dated with some degree of certainty to the period 1815 to 1820. Not only does the historical evidence tend to favour such a dating,[75] but the stylistic evidence supports it too. The 'Kingfisher' (cat.no. 33, ill. 22), for example, is based on a pencil study in the *Devonshire Rivers, No. 3, and Wharfedale* sketchbook, used in Yorkshire in about 1815 (cat.no. 50). Moreover the other bird drawings by Turner in the album – as will be seen later – conform stylistic-ally to the rest of the work he was producing in watercolour during this period. What is more difficult to determine is when the decision was first made to include water-colours as illustrations in the album. Since the volumes do not appear to have been bound until after 1819 (see under cat.no. 28), the idea of contributing watercolours could well have arisen at quite a late stage in the project, perhaps even as late as 1815 when it might have been prompted by similar work Turner was producing for other family albums such as *Fairfaxiana*. Be this as it may, there can be little doubt that

it was Turner's watercolours in the *Ornithological Collection* which set the tone, and provided the inspiration, for many of the contributions from the amateurs.

By far the most numerous and, arguably, the most successful of the watercolours Turner painted for the *Ornithological Collection* are those which concentrate on the head and neck of the bird only, accounting for fourteen – that is nearly three-quarters – of his total (cat.nos. 16–17, 19–20, 24–30, 32, 34–35). Since the majority of the watercolours in the album are likely to have been made from dead specimens, it has been suggested that this was a mode of representation whereby Turner could avoid having to confront the fact that the birds were no longer living.[76] If this is so, it should be seen as an effect rather than a cause. For this is a formula surely invented by the artist himself specifically to suit the requirements of the *Ornithological Collection*; the manner in which Turner deftly fades out the neck or breast of the bird

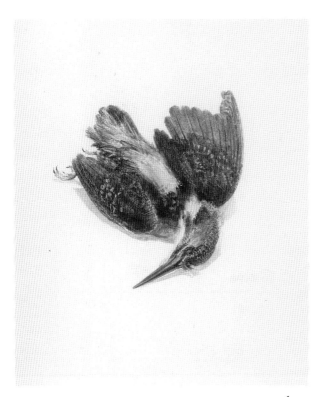

ill.22 J.M.W.Turner, 'Kingfisher', *c*.1815–20 (cat.no.33)

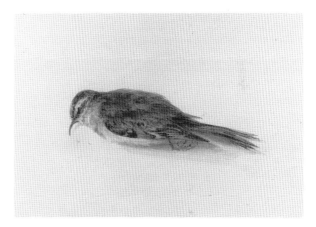

ill.23 J.Ibbetson, 'Dead Treecreeper', watercolour, *c*.1815–20, 119 × 176 mm (*Ornithological Collection*, volume I)

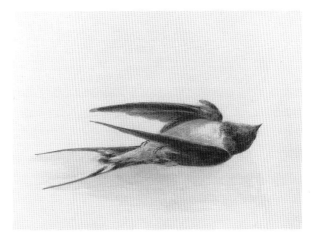

ill.24 Sir W.Pilkington, 'Dead Swallow', watercolour, *c*.1815–20, 165 × 229 mm (*Ornithological Collection*, volume II)

in these watercolours, usually by means of a dry brush, gives them a vignette-like appearance wholly in keeping with their purpose as illustrations to an album (see especially ills. 9, 10, 13 and 30).

Above all, such a formula was better suited to the artist's talents. For when Turner concentrated on the head and neck only, he was able to imbue the birds with an extraordinary sense of vitality. Not only, for example, are Ruskin's two favourites, the heron (ill. 30) and the peacock (ill. 10) full of life and character, but so too are the owl (ill. 9), the gamecock (ill. 28), the turkey (ill. 35) and the guinea-fowl (cat.no. 29). When, by contrast, Turner attempted to show the whole of the bird, alive in the traditional manner – whether, as in the case of the goldfinch (cat.no. 21) perching on a branch or, with the robin (cat.no. 22), simply standing on the ground – his designs were feebler in conception and much weaker in handling. It is perhaps significant that the artist did not again attempt a finished watercolour of a living bird, with the important exceptions of the two studies of teal in the Turner Bequest, where he decided to show the birds in movement, and with considerably more successful results (ills. 32 and 33).

The 'head and neck' formula was one which the amateurs seem to have found easiest to imitate. It was adopted by Mr Taylor in his 'Head of a Red-backed Shrike'

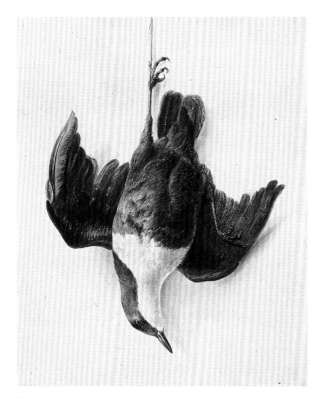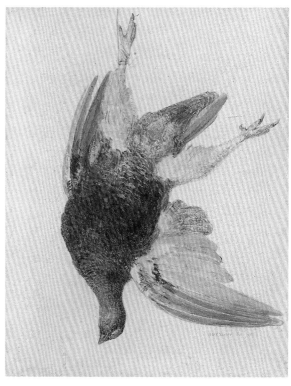

ill. 26 Mr Taylor, 'Dead Water Ouzel', *c.* 1815–20, water-colour, 182 × 152 mm (*Ornithological Collection*, volume III)

ill. 25 J. M. W. Turner, 'Red Grouse', *c.* 1815–20 (cat.no. 31)

(ill. 11), by Edward Swinburne in 'Head of a Bittern' (Appendix II), and moreover was the only method attempted by the lady amateurs in their drawings of water birds in the final two volumes of the *Ornithological Collection*. Here Miss I. Middleton's 'Head of a Mallard' (ill. 21) is superior to Lady Armytage's 'Head of a Shoveller' (ill. 20), for Miss Middleton has followed Turner's example in presenting the bird as a vignette, balanced within the centre of the page; Lady Armytage, on the other hand, has simply clipped the bird's neck and breast at the bottom of the page, with the result that her watercolour seems less resolved.

The remaining four watercolours by Turner painted for the *Ornithological Collection* also differ from conventional eighteenth-century bird portraiture in showing dead specimens. The dead kingfisher (ill. 22) and woodpigeon (cat.no. 23) cast a strong shadow over the surface on which they rest, and this was imitated by Ibbetson and Pilkington in their studies of a dead treecreeper and a dead swallow respectively (ills. 23 and 24). Turner's red grouse (ill. 25), on the other hand, is seen suspended upside down from one of its legs, a wing flapping forward to one side. Such a manner of representation is, of course, common in Western Art for studies of dead game, particularly with seventeenth-century Dutch still-life painters. It is possible that Turner may have found inspiration here in Walter Fawkes's own collection of seventeenth-century Dutch and Flemish pictures which included a number of still-life subjects (especially of dead game), two of which – by Jan Weenix and Melchior de Hondecoeter – Turner sketched hanging in their places on either side of the door of the library at Farnley (ill. 2, see cat.nos. 14 and 42). The artist was to experiment with more complex still-life groupings in two unfinished studies in the Turner Bequest (cat.nos. 42 and 43, and ill. back cover).

The 'Red Grouse' itself may not, in the end, have been included in the *Ornithological Collection* (see under cat.no. 31), although it surely inspired the only other similar watercolour in the album, Mr Taylor's highly accomplished study of a 'Dead Water Ouzel' (ill. 26). Indeed, it was Turner's studies of dead birds which appear to have had the most enduring influence on other artists such as Ruskin who, in turn, relayed it to many of his pupils. It was certainly these studies which the artist himself was most often to repeat in watercolours which were not intended for the *Ornithological Collection* itself.

Turner as a Bird Draughtsman

When Ruskin claimed that it was only at Farnley that Turner had made drawings of birds, he was clearly referring specifically to the watercolours the artist had made of birds alone, divorced from their natural setting. He did not mean to imply that Turner had otherwise disregarded bird life in all its manifestations, or that he had failed to observe or record such creatures in the rest of his work.

On the contrary, Ruskin was well aware that Turner had often made studies of birds in sketchbooks, particularly those which dated from the late 1790s. Indeed these studies were so high in Ruskin's priorities of items for display, that he actually detached some of them – from the *Swans* and *Salisbury* sketchbooks for example (cat.nos. 48 and 49) – for inclusion as separately mounted items in the selections he chose from the Bequest for exhibition in the second half of the nineteenth century. These might simply be examples of the artist's 'rapid memoranda of groups that pleased him, caught as he stood looking into his poultry yard';[77] or, perhaps, a rapid pen and ink notation of flocks of geese in flight, arising from or alighting onto the water (cat.no. 49). One of the sketches Ruskin admired the most was 'a Study of Two Swans' which, he felt, showed how skilfully and, above all, how truthfully the artist

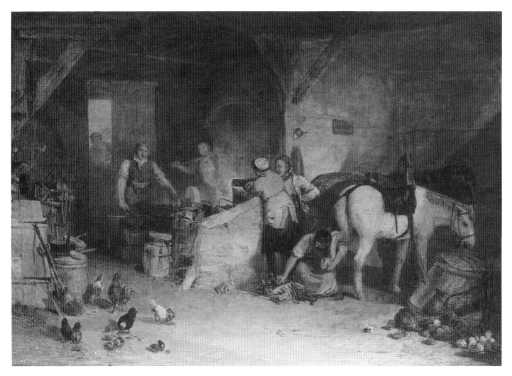

ill. 27 J. M. W. Turner, 'A Country Blacksmith Disputing upon the Price of Iron', 1807, oil on panel, 550 × 780 mm (Tate Gallery, Turner Collection)

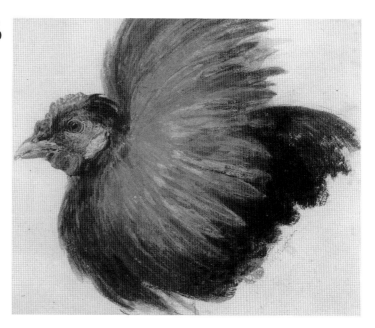

ill. 28 J. M. W. Turner, 'Gamecock', *c.* 1815–20 (cat. no. 24)

had captured the bend of the bird's neck, and the graceful and elegant proportions of its body (cat.no. 48). Such sketches were not designed to be translated into finished watercolours. They are notes in sketchbooks which reveal the power of the artist's perception, and his desire to record a little of everything which surrounded him in the natural world.

Some years later Turner began to include groups of birds in his finished work, particularly in the subjects of rustic genre which he painted towards the end of the first decade of the nineteenth century. In the oil he exhibited at the Royal Academy in 1807, for example, 'A Country Blacksmith Disputing upon the Price of Iron' (ill. 27), it would be difficult to miss the splendid passage in the left-hand foreground showing a group of chickens enjoying their feed (the cock bird stands alert, turned away from the viewer, perhaps distracted by the argument which is the subject of the picture). A similar cluster of feeding chickens appears in a subject engraved for Turner's *Liber Studiorum* under the 'pastoral' category in 1809, 'Farmyard with Cock' (cat.no. 46), and where it vies for our attention with a litter of pigs in the foreground. Meanwhile, in a watercolour which Turner exhibited in his own gallery the same year, 'Cottage Steps, Children Feeding Chickens'[78] (and which Walter Fawkes subsequently owned), domestic poultry have become the chief agent in the narrative.

From about 1815, when he first became involved in the *Ornithological Collection*, Turner began to include examples of bird life more conspicuously in some of his landscape watercolours, often views in Yorkshire. Indeed birds are sometimes seen as the exclusive occupants of a landscape from which the human presence has been banished. For example, a heron is the only sign of life in the panorama 'On the

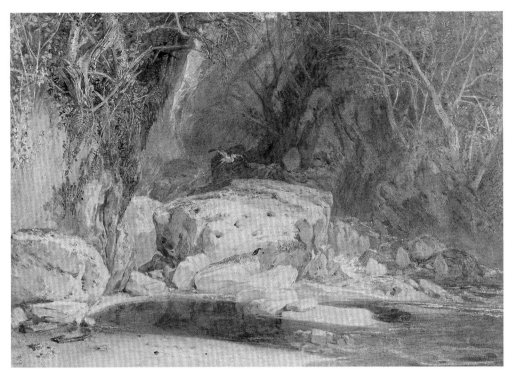

ill. 29 J.M.W. Turner, 'A Rocky Pool with Heron
and Kingfisher', *c.* 1815 (cat.no. 47)

Washburn, under Folly Hall',[79] *c.* 1815 (made for Turner's patron, Sir William
Pilkington) where it appears prominently in the foreground, balancing on one leg at
the edge of the river, awaiting an opportunity to dive in and seize its prey. In another
watercolour of about the same date, which probably shows a secluded dell in Wharfe-
dale, a heron has taken to flight[80] and soars over a large boulder on which a kingfisher
can just be made out perching below (ill. 29, cat.no. 47). It is perhaps not surprising
to observe that those species which Turner shows so convincingly and so lovingly
within their natural setting – the heron and the common domestic fowl – are amongst
the most characterful subjects he painted for the *Ornithological Collection* (ills. 30
and 28).

Turner's involvement in the *Ornithological Collection* between the years *circa* 1815
to 1820 should be measured within the context of the other work he was contribut-
ing to family projects at Farnley during the same period. There is no evidence to
show, for example, that he shared his patron's bookish enthusiasm for ornithology
or natural history, nor that he took more than a passing interest in the compilation
of the *Ornithological Collection* itself. In 1850, as we have seen, his memory was dis-
tinctly hazy with regard to his own contribution – though he seemed to remember
that his twenty watercolours had been pasted into the volumes. What he recalled
more readily was that a cuckoo had been his first successful shot on Farnley Moor
'in ernest [*sic*] request of Major Fawkes to be painted for the Book'.[81] This, indeed,

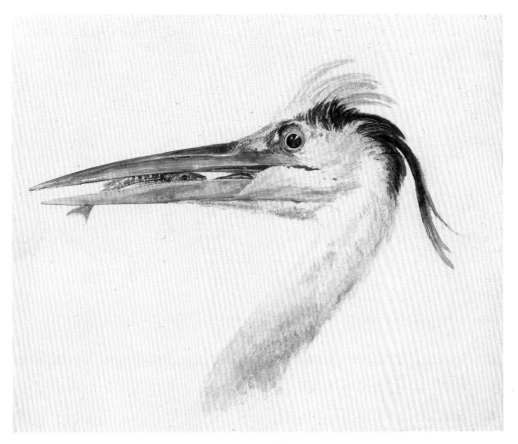

ill. 30 J. M. W. Turner, 'Heron', *c*. 1815–20 (cat.no. 34)

may be the most accurate reflection of how he first became involved in the project –
to amuse a young boy of seven. It is true that Turner was keen to protect the black-
birds' nests in his Twickenham garden from the local children, and that he enjoyed
making play on the similarity of his name 'Mallord' with 'Mallard';[82] indeed he may
even have gone bird watching at Farnley (see under cat.no. 44). But without the part
he played in the *Ornithological Collection*, there is no reason to assume he would ever
have made watercolour studies of birds at all.[83]

Stimulated by his contribution to the *Ornithological Collection*, however, Turner
was inspired to make other bird studies as well. Some of these follow the formula
adopted for the album in showing the head and neck of the bird only (cat.nos. 36, 37,
61 and 64), although two of them (cat.nos. 36 and 37) were almost certainly intended
for the volume of the *Ornithological Collection* which had to be abandoned. There
are also two studies of teal in the Turner Bequest (ills. 32 and 33). The majority of
the remaining watercolours, however, are studies of dead game (cat.nos. 38–40, 42–
43, 59–60, 63, 65) and these, one can assume, were probably also made at Farnley –
copied from specimens brought back, like the 'Red Grouse' (ill. 25) that Turner him-
self had killed, from the shooting expeditions which were such a regular feature of

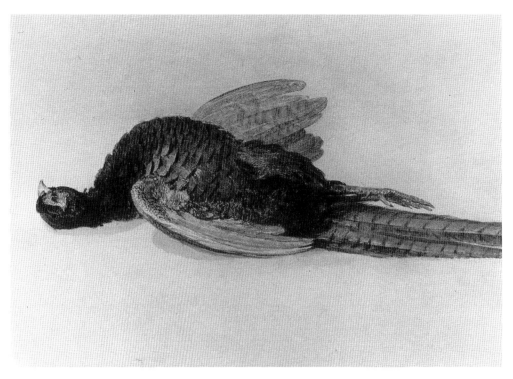

ill. 31 J. M. W. Turner, 'Dead Pheasant', *c*. 1815–20
(cat.no. 40)

the autumn calendar there (see cat.nos. 8, 10 and 13). In the same way that the
drawings Turner was to make at Petworth in the early 1830s are imbued with the
atmosphere of the house, its collection of old masters, and its 'solid, liberal, rich and
English' environment,[84] so too perhaps can these studies of dead game be seen to
reflect the pattern of rural life at Farnley, of which Fawkes's own collection of
seventeenth-century still-life paintings was an expression.

 These game studies by Turner vary considerably in their degree of finish. Some
of the more broadly-handled examples, such as 'Study of a Dead Pheasant' (cat.no.
39) may simply have been made for the artist's own interest. The two unfinished
studies of a dead pheasant and woodcock in the Bequest seem to be personal experi-
ments in the arrangement of a more complex still-life composition, although it is
conceivable that they are related to a commission for Fawkes which was never com-
pleted (see ill. back cover, and cat.nos. 42 and 43). However, some of the finished
watercolours of dead game seem rather to have been made for members of the
Fawkes family to keep. For example, Amelia Hawksworth, the daughter of Francis
Hawksworth whose task it had been to collect the feathers for the *Ornithological
Collection*, came to own[85] five bird studies by Turner (cat.nos. 36, 37, 59, 61 and 63)
of which two (cat.nos. 59 and 63) were studies of dead game. One of the latter was a
replica (cat.no. 63) of the red grouse (ill. 25) which Turner had painted for the
Ornithological Collection and which it appears he had been prevailed upon to draw

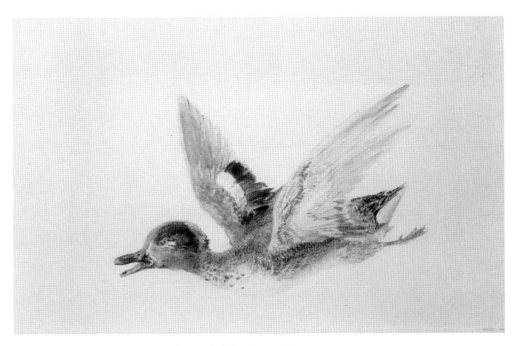

ill. 32 J. M. W. Turner, 'Study of a Teal Flying', *c*. 1820
(cat. no. 45)

– it was not his usual practice to make such duplicates – probably as a pair to the 'Dead Blackcock' (cat. no. 59) which she also came to acquire. Moreover, the version of a dead grouse by Turner which Ruskin owned (cat. no. 60), although horizontal in format and not of such high quality, is clearly inspired by the same subject in the *Ornithological Collection* (ill. 25). Indeed, many of the studies of dead game which Ruskin possessed (ill. 31, cat. nos. 38, ?39, 40, 65) were probably acquired directly from members of the Fawkes family themselves.

There are certain stylistic affinities between these additional bird studies by Turner and those which he made for the *Ornithological Collection*, and it can thus be assumed that they were painted about the same time, between *circa* 1815 and 1820. The two studies of teal in the Bequest (ills. 32–33) and the watercolours of fish (ill. 34 and cat. no. 52) may date from slightly later, but for stylistic reasons they can be considered as belonging to the same group. (The watercolours of fish certainly have more in common with Turner's bird drawings than with his later, more broadly-handled studies of marine fish, see under cat. no. 51).

With the exception of the 'Kingfisher' (ill. 22), which is based on a slight pencil study in the *Devonshire Rivers, No. 3, and Wharfedale* sketchbook of *circa* 1815 (cat. no. 50), most of Turner's bird studies appear to have been worked up in pencil directly onto the sheet itself in front of the dead (or in some cases, perhaps live) specimens. The starting point for the 'Peacock' (ill. 10), for example, was an outline sketch on the *verso* of the present watercolour; when it proved unsatisfactory, the artist simply turned over the page and started again. In the case of the study of fish

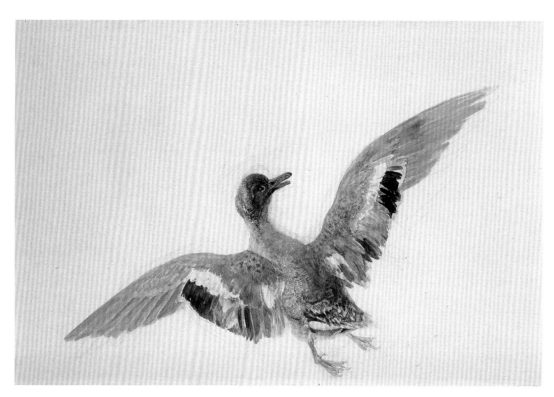

ill. 33 J.M.W. Turner, 'Study of a Teal with Outspread
Wings', *c*. 1820 (cat.no. 44)

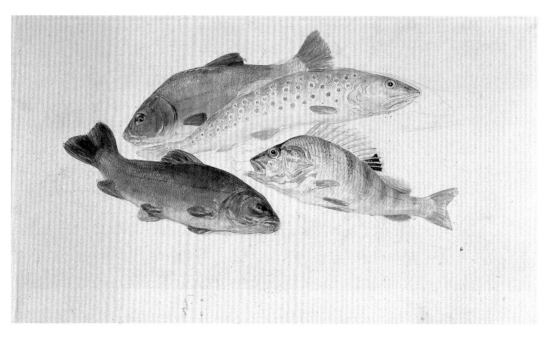

ill. 34 J.M.W. Turner, 'Study of Fish: Two Tench,
a Trout and a Perch', *c*. 1822 (cat.no. 51)

(ill. 34), Turner similarly abandoned an earlier attempt (cat.no. 52), this time starting on a new sheet. In some of his finished watercolours of birds, pencil outlines are quite prominent at the edge of the coloured image as, for example, is the case for the 'Moorhawk' (cat.no. 16) or the 'Goldfinch' (cat.no. 21). Others have a number of *pentimenti* – pencil marks which show where the artist has changed his mind in the course of the drawing and altered some of the contours (ills. 33 and 34). For example, 'Study of a Teal with Outspread Wings', being a more complex subject of a bird in movement, demonstrates the numerous attempts Turner made before he arrived at the correct position, and accurate proportions, of the bird's head and wings (ill. 33).

Once the underdrawing was finished, Turner would then apply the preliminary wash layers: the two studies of dead game in the Bequest (ill. back cover, and cat. no. 43) show what some of these drawings would have looked like when half-finished; the 'Robin' (cat.no. 22), indeed, was taken very little further than this stage. He would then resort to a variety of techniques to express the different textures of the plumage. Ruskin admired the skilfull way in which Turner was able to suggest the light, furry body feathers: speaking of the 'Study of a Teal Flying' (ill. 32), he described this as the 'peculiar execution by which the spotted brown plumage is expressed' (see under cat.no. 45). This lively, uneven finish was achieved by the application of a final layer of thicker and denser colour over the underlying wash, which was dragged across the surface of the paper with a dry brush to create a rough and scumbled appearance. It is a technique which is most evident in the heads of birds painted for the *Ornithological Collection* and where, as it has been seen, Turner fades out the neck to resemble a vignette (ills. 13, 30 and 9).

To create further textural variety, the artist might then add a few fingerprints. A large thumbprint, for example, is visible just below the eye in the head of a pheasant (cat.no. 25) painted for the *Ornithological Collection*, although such finger-prints similarly appear in Turner's studies of dead game (ills. 25 and 31, and cat. no. 38). Or he would create highlights by scratching out areas of colour to reveal the white of the paper below (see ills. 10, 22 and 31). Finally, although this was reserved only for the more finished and elaborate subjects (usually of dead game), Turner might occasionally add a touch of bodycolour – that is watercolour mixed with an opaque white pigment – usually to the tip of the head, as in the watercolour of a 'Red Grouse' (ill. 25), or occasionally, as in the 'Blackcock', to the body as well (cat.no. 59). More rarely still the artist might apply a light layer of gum, on the darkest and most densely painted areas of the bird's body (ills. 25 and 28). Many of these techniques, including dry brushwork, appear in other work by Turner in watercolour as early as 1809.[86] However they are used with greater regularity in watercolours dating from the same period as the bird studies themselves, such as some of the Yorkshire subjects of 1815 to 1818 and many of the Rhine drawings of 1817 as well.[87]

Although Ruskin spoke of the technique which Turner used in his bird drawings as 'inimitable' (see under cat.no. 45), he was nevertheless inspired to make similar

studies of his own. For example, he painted a 'Dead Pheasant' which is very close to the version by Turner in the Whitworth Art Gallery (ill. 31, see under cat.no. 40), and also made studies of ducks which evidently reveal the artist's influence (see under cat.no. 45). Moreover his study of a kingfisher (cat.no. 57), although it shows the bird live, was probably inspired by the watercolour Turner made for the *Ornithological Collection* (ill. 22) and which he had so admired (see under cat.no. 33). Indeed, so highly did Ruskin value the example which Turner set in his bird drawings that he gave the watercolour of a dead pheasant by the artist which he himself owned (cat.no. 38) to the Oxford Drawing School so that it could serve as a model for students to imitate. It was surely with such encouragement from Ruskin that William Henry Hunt (1790–1864) first turned to making detailed watercolour studies of birds.[88]

Ruskin's bird studies however, differ from Turner's in a number of important respects. Firstly they are usually painted in bodycolour or, as in the study of a kingfisher (cat.no. 57), in watercolour and bodycolour. He advised a pupil that when painting plumage, after adding the pencil work she should proceed to 'colour at full speed – mixing all the darks with Chinese white that they may crumble and bloom'.[89] Secondly, and more fundamentally, however, Ruskin goes one step further than Turner in attempting to express the underlying structure of the bird. Turner's bird studies impress us with the virtuosity of their technique, but leave us with little understanding of the structure of an individual species. Ruskin's approach, by contrast, was highly scientific and analytical. He made separate studies of birds' wings, as well as microscopically detailed watercolours of feathers, some of which he might show enlarged for comparison with others life size, as for example in the drawing 'Feathers of the Kingfisher's Wing and Head, Enlarged with, below, a Group of the Wing Feathers Real Size' (cat.no. 58). He ticked off one of his pupils, Miss Elizabeth Emily Murray (whom he had encouraged to make similar studies) when he discovered that she had drawn a feather one-tenth of an inch too wide – a mistake, he wrote to her, which was 'quite awful'.[90] In *The Laws of Fésole* he defined at some length the different textures of a bird's plumage, and explained the 'absolutely needful' nomenclature of the different parts of a feather (see under cat.no. 58). It is, perhaps, something of an irony that Ruskin's bird drawings are more revealing of that truth of inner form which the critic so passionately believed was fundamental to an understanding of Turner's work, and yet which was so conspicuously lacking in the very drawings which he set out to imitate.

However, such an analytical approach was hardly Turner's concern. A large proportion of his bird studies were made to embellish a family album which was assembled in a spirit of amateur enthusiasm, not scientific exactitude. The watercolours of game birds he painted, perhaps during moments of relaxation at Farnley and possibly inspired by Fawkes's own collection, are still-life studies, not rigorous investigations into bird structure. When required to try his hand at this unfamiliar branch

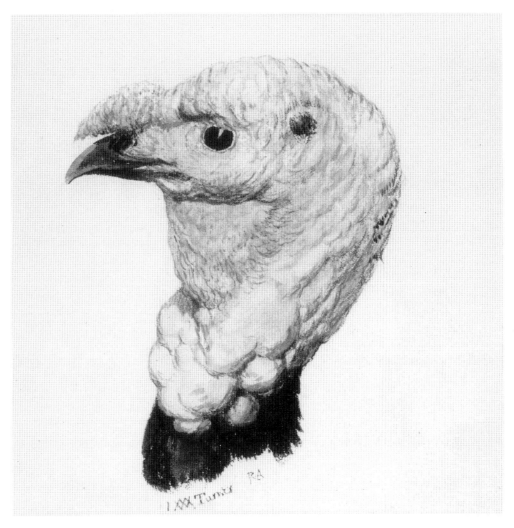

ill. 35 J. M. W. Turner, 'Turkey', *c.* 1815–20
(cat. no. 27)

of art – bird drawings, after all, were not the normal preserve of the landscape painter – Turner brought to the task all the freshness of vision and originality of approach which is characteristic of his inventive mind. The 'Heron' and the 'Peacock', the 'Owl' or the 'Turkey' (ills. 30, 10, 9 and 35) are a far cry from the professional products of his contemporaries or his predecessors; they are, in fact, timeless in their appeal. If, in an assessment of Turner's work in general, a modern critic might not rank Turner's bird drawings as highly as Ruskin did, he would still be forced to appreciate the significance of his comment that they had been made when the artist was 'in happy youth at Farnley'.[91]

Notes

Publications listed in the bibliography are given an abbreviated reference.

1 The only other watercolours in 'Class 1st' were 'Munro's Lake Lucerne, morning'; 'Munro's Pass of Splugen'; and 'Fawkes's Vignettes from History of Cromwell – or Commonwealth' (i.e., *Fairfaxiana*). See Cooke and Wedderburn, 1903–12, XIII, pp.xlviii–xlix.

2 As David Hill explains (1988, p.27), a manuscript catalogue compiled by Hawksworth Fawkes in 1850 of the Farnley Hall Turners (see bibliography) lists together eighteen of the watercolours from the *Ornithological Collection*, in the order in which they would have appeared in the album. The exceptions are the 'Ring Dove' and 'Dead Grouse hanging, killed by the artist' which appear on an earlier page, suggesting that they had already been removed. See under cat. nos. 23 and 31.

3 Edith Mary Fawkes, 1900, p.619 (see Cooke and Wedderburn, 1903–12, XII, p.lvii). Turner's watercolours were mounted opposite a blank page, and would not have been rubbing against the feathers themselves. However the weight and bulk of the feathers had caused many of the pages in the album to buckle badly, and hence Ruskin's concern. See also under cat.no.15.

4 *Ibid.*

5 Edith Mary Fawkes, 1900, p.622 (see Cooke and Wedderburn, 1903–12, XXXIV, pp.670–71).

6 Cooke and Wedderburn, 1903–12, XIII, p.274.

7 *Idem*, p.370.

8 Armstrong, 1902, p.88 and Finberg, 'Turner at Farnley', 1912, pp.90–91.

9 Hill, 1988, p.9.

10 See especially Hill, 1980; Hill, 1984; and Hill, 1988.

11 Gage, 1987, pp.160–63.

12 See Wilton, 1979, nos. 582–631.

13 Hill, 1980, pp.49–50.

14 These included a wheelchair, breast-plate and helmet, candlesticks and a drinking-mug which belonged to General Fairfax, and a hat and sword which Cromwell owned (see Hill, 1980, p.49).

15 Armstrong, 1902, p.88 he said were cut up for this album were Meyrick's *Ancient Armour*, Strutt's *Dress and Habits of the People of England*, Lodge's *Portraits* – to which list one should also add Stodhart's *Monuments* (see Edith Mary Fawkes, 'Turner at Farnley', n.d.). As Edith Mary Fawkes commented, it appears to have been essentially a 'collection of prints illustrating English History'.

16 In 1810 Fawkes published *The Chronology of the History of Modern Europe*. Accord-ing to David Hill (1980, p.49), the four frontispieces were made to extra-illustrate a copy of this work, although this could only be true if the grangerised 'History of England' formed part of *The Chronology* itself.

17 Fawkes was elected M.P. for Yorkshire in 1806–7, and became an 'active member of the advanced section of the Whig party', supporting the anti-slave trade movement as well as Parliamentary reform. His political views are expressed in a speech on *Parliamentary Reform*, 1812, and in *The Englishman's Manual; or, a dialogue between a Tory and a Reformer*, 1817; see *Dictionary of National Biography* (hereafter D.N.B.) 1908–9, p.1133.

18 Nares, 1954, p.1717, who is in no doubt that it was Fawkes himself who assembled the library. Indeed many of the volumes, in addition to the family crest, bear the initials 'WF'.

19 Cooke and Wedderburn, 1903–12, XXII, pp. 248–49.

20 *Dictionary of Scientific Biography*, ed. Charles Coulston Gillispie, New York, 1970–80; entry on Linnaeus (1707–1778) in vol. VIII, pp. 374–81 by Sten Lindroth. *Systema Naturae* presented his new system for the animal, plant and mineral kingdoms. It was up-dated, expanded and revised many times during his lifetime. The definitive 10th edition (1758–59) included only animal and plant species.

21 Copy in collection of Clive Wainwright, 17th edn. Fawkes's name may well appear in earlier editions of the *Companion* as well.

22 For a lively description of the Bullock museum see Altick, 1978, chapter 18.

23 Jessie M. Sweet, 'William Bullock's Collection and the University of Edin-burgh 1819', *Annals of Science*, vol.26, 1970, pp. 23–32. The first companion to the museum was published in Sheffield in 1799 ('Some Museums Of Old London, II: William Bullock's London Museum', by W.H.Mullens, *Museums Journal*, vol.17, 1917–18, p.132).

24 *Leigh's New Picture of London*, 1818, pp.382–83.

25 The 1809 *Companion* (7th edn) states that: 'In a short time will be published . . . in two volumes . . . An Accurate Description of the Subjects of Natural History, foreign and other curiosities . . . in the Liverpool Museum; illustrated by upwards of thirty etchings, by Howitt . . .' The 1813 Companion (15th edn) contains a similar announcement. Howitt was quite a prolific etcher, especially of birds, animals and sporting subjects (see D.N.B., pp. 123–24 and Snelgrove, 1981, pp. 105–9).

26 The 'Red Phalarope', the 'Eared Grebe' and the 'Shearwater' all bear the inscrip-tion 'Mr Bullo[ck]' in pencil (the last two letters being trimmed off the page). These three watercolours by Howitt, together with another one of a tern, were loosely inserted into one of the volumes of Fawkes's *Synopsis of Natural History*. All four, however, are larger than the illus-trations in that work and all have traces of brown paper on their *versos* indicating that they were lifted off a brown page. Since all four birds are listed in the section of Bewick's 'Water Birds' ranging from 'Of the Phalarope' to 'Of the Mergus', there can be little doubt that they were intended for the volume of the *Ornithological Collection* which was abandoned when the feathers proved too difficult to collect. Two watercolours by Turner were probably also intended for this volume (see cat.nos. 36 and 37). Graves's *British Ornithology*, 3 vols, 1811–21, included illustrations of birds by Howitt, some of which were copied from specimens belonging to Bullock, e.g. the egret and the ptarmigan (see also Jackson, 1985, p. 195).

27 Moreover, in the catalogue of the exhibi-tion at the Royal Academy in 1814 (when he exhibited a painting of 'Dead Game'), Howitt gave his address as 'Bullock's Museum, Piccadilly'.

28 It is inscribed on the inside front cover 'Walter Fawkes Junior Given by his Papa', which implies it had been given him as a young boy. In any case Fawkes was only twenty-three when his father died in 1792.

29 For example, J. Wolf and B. Meyer, *Naturgeschichte der Vogel Deutschlands*, 2 vols, 1805; A. Wilson, *American Ornithology*, 9 vols, bound in five, 1804–14; C. Teeminck and M. Laugier, *Nouveau recueil des planches coloriees d'oiseaux*, 4 vols (of 5), Paris, 1821; and J. Latham, *A General History of Birds*, 11 vols, 1821–28.

30 Since Bewick specifies that this publica-tion is on European birds, it cannot be the same as that listed in n.29.

31 Supplements were published in 1821 and 1822. The contents of the accompanying list in the letter indicate that Bewick must be referring to the 1821 supplement, when twenty-two land birds and twenty-four water birds were added to the *History of British Birds* (see Roscoe, 1973, p.115).

32 Thomas Pennant (1726–1798) and John Latham (1740–1837). Bewick would be referring to Pennant's *The British Zoology*, first pub. 1766, which chiefly devoted to birds although it also included some quadrupeds (see also under cat.no.55). Latham wrote a number of ornithological books: by 1822 he had

already published *A General Synopsis of Birds*, 1781–85, as well as the *Index Ornithologicus*, 1790, which modified the Linnean classifications; in that year he had also just started to issue *A General History of Birds*, 1821–28, 11 vols, a copy of which Fawkes owned (see under n.29), although the latter died (in 1825) during the course of its publication (for Pennant, see D.N.B., pp. 765–68, for Latham, *idem*, pp. 605–6).

33 In an 1805 edition (possibly one of the 'best' copies referred to by Francis Hawksworth in a letter of 27 Feb, 1809, see Appendix I, no.1) and in an 1821 edition (to which Bewick sent a handwritten supplement in 1822, see Appendix I, no.9 and n.31). Fawkes also owned two editions of Bewick's *A General History of Quadrupeds* and a copy of *The Fables of Aesop and Others*, 1818.

34 Walter Fawkes had three younger brothers: Francis Ramsden Hawksworth (1774–1824/5); Ayscough Hawksworth, Rector of Leathley (d.1825, see obituary, *The Gentlemen's Magazine*, 1825, pp. 648–49, under 'Clergy Recently Deceased'); and Richard Hawksworth (1780–1816) who was killed in a shooting accident at Farnley in 1816 (see Hill, 1988, p.18). Francis Hawksworth had two daughters, the younger of which, Amelia, came to own five watercolours by Turner (see under cat.no.38 and n.85).

35 It is not clear from the letter whether Hawksworth was paying for two sets of each of the publications of Bewick's *History of British Birds* and *A General History of Quadrupeds*, or just one copy of each. Certainly two sets of the *History of British Birds* would have been required for the *Ornithological Collection*, since some of the text pasted down in the album (e.g. the Contents Lists, see ill.6, and 'Explanation of the Technical Terms') is printed on both sides of the paper.

36 The 1809 edition was the first and only edition to describe the two volumes of the *History of British Birds*, 'Land Birds' and 'Water Birds', as 'Part I' and 'Part II'; the contents list at the back of Volume I of the *Ornithological Collection* is entitled 'Contents of the First Part' (earlier editions, e.g. that of 1805, referred to them as 'volumes' and thus to 'Contents of the First Volume'). Moreover, the 1809 edition had a more 'utilitarian' and economical layout whereby the text spilled out from one bird to the next (Roscoe, 1973, p.88) and this would presumably have been ideal for cutting up. Perhaps Bewick supplied this edition in an unbound copy.

37 Vol. I now has 124 pages; vol. II, 108; vol. III, 106; vol. IV, 96; and vol. V, 94. The white pages in vols. I–III are watermarked 1810; those in vols. IV–V, 1813.

38 Turner's 'Moorhawk' was similarly selected for the very first frontispiece in the volumes, that introducing 'Birds of Prey: the Falcon tribe', in preference to Howitt's watercolour of that bird which

was pasted down in its listed position (see Appendix II).

39 Of the remaining ten watercolours by Turner, nine could not serve as frontispieces since they belonged to the same genus as others by him which already fulfilled this function; the kingfisher, meanwhile, was listed independently by Bewick.

40 D.E. Allen, 1976, p.29; see also Jackson, 1985, pp. 161–63.

41 'A Catalogue of the Portland Museum, lately the property of the Duchess Dowager of Portland, Deceased . . . London 1786'. A copy is in the Zoology Library at the Natural History Museum (85A o. B.).

42 They differ, for example, from those in the copy in the Zoology Library at the Natural History Museum (18 f L) both in this respect, and in their inclusion of careful shading; moreover they lack figure numbers immediately below the eggs themselves.

43 Jackson, 1985, p.168.

44 See Casey A. Wood, *An Introduction to the Literature of Vertebrate Zoology*, McGill University Publications, Oxford University Press, 1931, p.435; the copy in the McGill University Library in Montreal has 145 eggs on 90 leaves. Only two or three other copies are known to exist.

45 In *Harmonia Ruralis: Or an Essay Towards a Natural History of British Song Birds*, Bolton claimed that: 'The eggs of many of the British birds are excellently figured in a superb work, now publishing by Mr Lewin. These were painted from the natural subjects in the Portland Museum, most of which subjects were collected in Yorkshire, and communicated to that noble repistory by me' (Preface; copy in Zoology Library, Natural History Museum, 18 f B). Some of the specimens had probably been collected by his brother, Thomas Bolton (see Jackson, 1985, pp. 174–75).

46 Gage, 1980, no.323.

47 Hill, 1988, p.18. Major Fawkes was the youngest of Walter Fawkes's four sons; since he was born in 1809, he would have been about six or seven when Turner became involved in the project.

48 E. M. Fawkes, 'Turner at Farnley', n.d.

49 We know from the surviving correspondence that Fawkes paid for the Bewick wood-engravings as well, presumably, as for the 'Small Sketches' by Bewick (see Appendix I, no.8, and no.2). One can probably also assume that Turner was paid for his contribution.

50 Charles John Brandling married Hawksworth's sister, Frances Elizabeth, who is referred to as 'Fanny' in a letter written by Hawksworth himself (Appendix I, no.3). On her death he remarried, in 1824, Henrietta Armytage, second daughter of Lady Armytage who contributed watercolours to the *Ornithological Collection* (see Appendix II). Gosforth is just outside Newcastle,

and Gosforth House is listed in N. Pevsner and Ian A. Richmond, *The Buildings of England: Northumberland*, 1957, pp. 158–59. Many of the feathers for the 'Water Birds' were probably collected from birds which frequented the lake at Gosforth. For example, in vol.V of the *Ornithological Collection*, the teal feathers were from a specimen 'killed out of a flock of nine, which visited the lake at Gosforth Dec 1812'; those of the golden-eye were from the '*first* bird killed on the Lake at Gosforth by C. J. Brandling'; and those of the garganey bear the description that 'A flock of these ducks bred and flourished at Gosforth for several years. Bewick thought that they never bred in England'. See also Appendix I, no.7.

51 See n.34.

52 This comment is crossed through in the original manuscript (see Appendix I, no.3). This letter, originally written by Francis Hawksworth to his brother Ayscough, was then taken to Bewick in Newcastle and used as a list; irrelevant or personal matter relating to the family was thus crossed through.

53 See Hill, 1988, p.14.

54 Hawksworth Fawkes made a caricature sketch of Waterton on one of the latter's visits to Farnley (repr. Wakefield Art Gallery and Museums, *Charles Waterton 1782–1865 . . .*, 1982, no.99, p.29).

55 Hill, 1988, p.14. Walker apparently knew Fawkes well. It has also been suggested that Turner based the depiction of four figures in his watercolour of *Leeds*, 1816 (Wilton, 1979, no.544) on examples in Walker's *The Costume of Yorkshire*, 1813–14 (see Daniels, 1986, p.12).

56 D.N.B., pp. 906–8.

57 'Advertisement' to the first edition of the 'Water Birds', quoted Roscoe, 1973, p.71.

58 See n.26.

59 The final two volumes contain paper watermarked 1813, compared with the earlier volumes watermarked 1810 (see n.37); presumably, then, they were assembled and possibly also bound later. One cannot be certain that the albums were bound up after rather than before the pages had all been assembled, but all the evidence suggests this was so. It would have been impossible to predict in advance how many species might have to be left out, or to allow for the inclusion of odd specimens at a later stage – e.g. 'the sparrow killed at Wheatley, Nov. 1819' in vol.I (the inclusion of the latter also tends to confirm that the albums were not bound until after 1819, see under cat.no.28); and it would have been difficult to allow in advance for the possibility of more than one watercolour being included of the same species (see Appendix II). Moreover, the fact that the volumes are guard sewn – that is the spine was bulked out by the addition of narrow strips or folds of paper so that they could accommodate the bulkiness of the feathers (see ill.7 and under

cat.no.21) – would also tend to confirm that the volumes were bound up afterwards.

60 Lewin's illustrations of birds' eggs now began to be placed in a position which the watercolour illustrations should have occupied, and were frequently not even named. Feathers were not collected in either of the two volumes for the Egyptian goose, red-breasted goose, white-fronted wild goose, bean goose, bernacle, eider duck, velvet duck, scoter, hook-billed duck, red-breasted shoveller, bimaculated duck, ferruginous duck, crested corvorant and shag.

61 Edward Swinburne Senior is often confused with Edward Swinburne Junior (1788–1855), probably because the former was inadvertently left out of *Burke's Peerage*. Edward Senior was the brother of Turner's patron, Sir John Edward Swinburne, 6th Bt. (1762–1860); their portraits were both painted by Gainsborough (see E. Waterhouse, *Gainsborough*, 1958, pls.253–54). Edward Junior was the son of Sir John Edward (thus Edward Senior's nephew) and the uncle of the poet, Algernon Swinburne. Because of the confusion, it is often assumed that Edward Junior was also an artist and, indeed, that he took lessons from Turner (Wilton, 1987, p.88). However, recent evidence suggests that all the watercolours by 'Edward Swinburne' known to exist are probably by Edward Senior, an artist of considerable talent (see n.74).

62 Wilton, 1979, nos. 386, 390, 400 and 691–92. See Hill, 1981/2, pp.2–3, who claims that Sir John's purchase of *Mercury and Herse* in 1813 (Butlin and Joll, 1984, no.114) was his 'only documented venture' into Turner patronage.

63 He succeeded to the title in 1861 on the death of his nephew, Charles Ibbetson, the 5th baronet. In 1825, he assumed the additional surname of Selwin, and apparently sometimes used this name alone as a signature (see Mallalieu, 1976, p.188).

64 Repr. Wilton, 1987, p.117; because they were amateurs, their names are inscribed at the bottom of the plinth. Swinburne sent a watercolour of a 'Plover' to the exhibition (no.18) and Ibbetson a 'View of Venice' (no.14), later replaced with a view on the 'Island of the Tiber, Rome' (two differing copies of the exhibition catalogue are in the V & A Library).

65 Baptised 1775; later became the 8th baronet. For the watercolours by Turner he purchased, see Wilton, 1979, nos.527, 534 (and see ill.17), 535–36 and 538. The Pilkingtons were also related to the Fawkes family by marriage, see Hill, 1980, p.47.

66 *The Diary of Joseph Farington: Volume VI April 1803–December 1804*, ed. K. Garlick and A. Macintyre, 1979, pp. 2350–53.

67 She married in 1791, and died in 1834.

Her husband's younger brother, Godfrey Wentworth of Woolley married Walter Fawkes's sister, Amelia, in 1794. See also n.50.

68 Listed as 'Fanny' in *Burke's Peerage*, and as Frances Elizabeth Fawkes in Foster, 1874. She remained unmarried.

69 Foster, 1874, includes the Middleton family of Stockeld Park, nr. Wetherby, Yorkshire, although there is no mention of 'Miss I. Middleton'. 'Mr Taylor' could conceivably be the Thomas Taylor who assisted Théodore de Bruyn paint the *grisailles* in the dining-room at Farnley (see under cat.no.5) and whom Nares identifies as the 'T. Taylor' who exhibited landscapes at the Royal Academy between 1792 and 1811 (Nares, 1954, p.1810). Another artist called Stephen Taylor exhibited many subjects of dead game at the Royal Academy between 1817 and 1849.

70 The 'Golden Eye' is close to a drawing of a dead partridge in a Swiss collection and to a study, also of a dead partridge, which was included in a folio of drawings at Sotheby's, 14 July, 1988 (lot 5). The latter also included other drawings of birds, especially a watercolour of a dead snipe with a wood-engraving of that species by Bewick pasted onto the *verso*. Other watercolours, of the head of a heron and head of a coot, have also turned up recently with Bewick wood-engravings on their *versos*. All these drawings, with the exception of the dead partridge in a Swiss collection, share the same provenance as cat.nos. 36, 37 and 61, being originally in the collection of Francis Hawksworth's daughter, Amelia (see n.34). Presumably, then, there were other albums compiled by members of the Fawkes family similar to the Farnley *Ornithological Collection*.

71 Williams, 1952, p.27.

72 Williams (1952, p.196) says Howitt also copied from specimens in the menagerie at the Tower of London.

73 The 'Pied Flycatcher' in volume II (see Appendix II) was probably a frontispiece only because it happened to be the first of the two birds listed by Bewick under that genus, and because there were no other watercolours in this section.

74 There are examples of Swinburne's work in the Victoria and Albert Museum, British Museum, and Whitworth Art Gallery, Manchester; there is also an accomplished copy by Swinburne in the Yale Center for British Art after Turner's watercolour of 'Dunstanborough Castle' (Wilton, 1979, no.284). See also William Drummond, Summer Exhibition 1980, June 12–July 12, nos. 113–19.

75 For Major Fawkes (b.1809) to have shown an interest in the project, he would surely need to have been at least six or seven (see under n.47), which brings one to 1815 or 1816; and in those years Turner made long summer visits to

Farnley (previous and subsequent visits tended to be in the winter). Moreover Turner was more intimate with the family by 1815–20.

76 Hill, 1988, pp.18–20.

77 Cooke and Wedderburn, 1903–12, XIII, p.275.

78 Wilton, 1979, no.490, and repr. p.115.

79 *Idem*, no.538; see also Hill, 1980, no.47.

80 A heron is also seen (rather roughly sketched in) flying low over the surface of the lake in Turner's watercolour of 'Lindley Hall and Lake Tiny', *c*.1815; see Wilton, 1979, no.621 and Hill, 1980, no.60.

81 Gage, 1980, no.323, and see n.47.

82 See Cooke and Wedderburn, 1903–12, XIII, p.274 and Hill, 1988, p.20.

83 A pastel 'Study of dead ducks and other birds' in the Turner Bequest (CXXI–O) which Finberg dated to *c*.1802–10 (1909, p.334), and which Ruskin exhibited at Marlborough House in 1857–58 as belonging to the artist's 'first period' (Cooke and Wedderburn, XIII, 1903–12, p.274) is almost certainly not by Turner.

84 Benjamin Robert Haydon, quoted Wilton, 1987, p.171 where he also reproduces a selection of the Petworth watercolours.

85 It is not known when Amelia Hawksworth was born, only that she married in 1844. Unless she married late, it seems unlikely that the bird studies by Turner she owned were given her directly by the artist as is traditionally thought (see under cat.nos. 36, 37, 59, 61 and 63), but rather that she inherited them from her father.

86 For example, in 'Bolton Abbey', Wilton, 1979, no.532.

87 A point also made by Hartley, 1984, p.45. See, *passim*, Wilton, 1979, nos. 538–631 and nos. 636–86.

88 See, for example, *passim*, Witt, 1982, nos. 578–778.

89 Letter to Elizabeth Emily Murray (b. 1847) dated 4th March ? 1887, addressed from Brantwood (British Museum). Ruskin was referring to one of her studies of feathers.

90 Letter addressed from Brantwood, n.d., ?*c*. 1887 (British Museum).

91 Cooke and Wedderburn, 1903–12, XXII, p.530.

Catalogue

All works are by Turner unless otherwise stated. Measurements are in millimetres, height before width (inches are given in brackets). Provenance is only supplied for works by Turner; where the author deems it important, references may explain where a watercolour is reproduced elsewhere (in colour), or discussed in the literature. 'w' refers to the catalogue of watercolours in Andrew Wilton's *The Life and Work of J. M. W. Turner*, 1979; for other catalogue references (e.g. Herrmann and Hartley) see bibliography. Items in the Turner Bequest are referred to by the initials TB, followed by a number from Finberg's *Inventory* (see bibliography) and then their Tate Gallery accession number.

The Catalogue is divided up into the following five sections:

WALTER FAWKES AND FARNLEY HALL (cat.nos. 1–15)
Many of the commentaries here are indebted to recent publications by David Hill (especially Hill, 1980, and Hill, 1988; see bibliography).

TURNER'S BIRD AND GAME STUDIES (cat.nos. 16–50)
The technical description of the twenty watercolours from the *Ornithological Collection* (cat.nos. 16–35) is closely based on the entries in David Hill's *Turner's Birds*, 1988. As in Hill, the modern title of the bird is given first; that in brackets is the name used by Hawksworth Fawkes in his catalogue of the Farnley Hall Turners compiled in 1850 (see bibliography and note 2). The watercolours are catalogued in the order in which the author believes (occasionally differing from Hill) they would have appeared in the *Ornithological Collection*. Like Hill, she doubts the authenticity of some of the signatures on the watercolours, many of which appear partly in the form of a monogram. Those applied in wash in a colour also found in the image itself she regards as authentic (cat.nos. 18, 19, 22, 24, 27, 29, 31 and 33); those in pen and brown ink she suspects to be imitations (cat. nos. 25, 26, 30 and 32). The authenticity of all twenty watercolours themselves (the attribution of cat.nos. 21 and 22, for example, has sometimes been questioned) she does not doubt.

TURNER AND ANGLING (cat.nos. 51–54)
Turner's later and more broadly-handled watercolours of marine fish (see w 1399–1404) have deliberately been omitted from this section.

BIRD DRAWINGS BY OTHER ARTISTS (cat.nos. 55–58)
BIRD DRAWINGS BY TURNER NOT EXHIBITED (cat.nos. 59–62)
BIRD DRAWINGS BY TURNER, WHEREABOUTS UNKNOWN (cat.nos. 63–67)

WALTER FAWKES AND FARNLEY HALL

BRITISH SCHOOL, EARLY NINETEENTH CENTURY

1 *Portrait of Walter Fawkes (1769–1825)* *c.*1815

Pastel 780 × 610 (30¾ × 24)
Private Collection

By the time of his death in 1825, Walter Ramsden Hawksworth Fawkes had assembled the largest single collection of Turner's work ever privately owned, amounting to over 250 watercolours as well as 6 oil paintings. It is indeed as a patron of Turner and a lover of the fine arts that Fawkes is chiefly remembered. Yet he was a man of wide intellectual and social gifts: M.P. for the County of York from 1806 to 1807, High Sheriff of Yorkshire in 1823, a talented writer on subjects ranging from politics and history to natural history, a keen agriculturalist, Fawkes was a man 'universally esteemed for his urbanity' and 'an excellent landlord as well as a kind master' (obituary, *The Gentleman's Magazine*, 1825, p. 468). Here he is presented not only as a patron of Turner – a portfolio of the artist's drawings leaning against the table nearby – but also as a genial and much-loved country squire.

It has been suggested that this portrait is by John Raphael Smith. However Smith died in 1812, and the evidence both of the furnishings and of the sitter's age (Fawkes looks here in his mid-40s) suggest that it was painted a few years later, *c.*1815, about the time Turner first became involved in the *Ornithological Collection*.

4

2 *View of the Wharfe Valley from Otley Chevin* *c.*1808

Pencil 451 × 591 (17¾ × 23¼)
Inscribed: 'ling' on distant hill; 'river': '16 high'
T B CLIV N
D 12112

On his visits to Farnley, Turner often drew the panorama looking northwards across the Wharfe Valley from Otley Chevin. In this example, Farnley Hall itself can just be made out in the far right-hand distance on the crest of a hill, above the junction of the rivers Wharfe and Washburn. In the centre is another house owned by Fawkes, Caley Hall (demolished 1964), the park of which he kept regularly stocked with game for the shoot (see under cat.no. 8); in the left-hand distance are the peaks of the Cow and Calf rocks above Ilkley. Masons can be seen quarrying stone in the foreground.

This sheet is one of ten large pencil drawings in the Bequest which may originally have formed a single roll sketchbook (Hill, 1980, p. 28). Since one of the subjects was used for a finished watercolour dated 1809, all ten can probably be dated to 1808, the year of Turner's first visit to Farnley Hall.

3 *View of Farnley Hall: the 'New House' from the East* *c.*1816

Bodycolour and black chalk on buff paper
311 × 394 (12¼ × 15½)
PROV: Walter Fawkes; by descent to present owner
Private Collection (w 587)

When Walter Ramsden Beaumont Hawksworth Fawkes inherited the Farnley Estate in 1786 from his cousin Francis Fawkes, he commissioned a new wing from John Carr of York (the original, Jacobean house can be seen in Turner's watercolour to the right). The 'New House' was finished by 1792, the year in which Fawkes died, and it was left to his son, Turner's patron, to furnish the spacious and elegant new rooms (see cat.nos. 4 and 5). The South front of the Carr wing, with the projecting bay, commands magnificent views across Wharfedale towards Otley Chevin.
[illustrated page 11]

4 *The Drawing Room, Farnley Hall* 1818

Bodycolour on buff paper 315 × 412 (12⅜ × 16¼)
PROV: Walter Fawkes; by descent to present owner
Private Collection (w 592)

Between about 1815 and 1819 Turner made a series of freely-handled bodycolour 'sketches' of the house, grounds and neighbourhood of Farnley Hall (see also cat.nos. 3 and

5–10) for his patron Walter Fawkes, which the latter seems to have referred to as 'the Wharfedales' (for example in a letter to Turner of *c*.1818, see cat.no.11). 'The Drawing Room' is one of the few in the series which can be accurately dated, in this case to Turner's visit to Farnley in the autumn of 1818; for it shows hanging above the fireplace the artist's painting of 'Dort, or Dordrecht, the Dort Packet-boat from Rotterdam Becalmed' (Butlin and Joll, 1984, no.137) which Fawkes had bought that year from the Royal Academy as a twenty-first birthday present for his eldest son, Hawksworth Fawkes. Two other marines by Turner can also be identified hanging amongst Fawkes's collection of Old Masters: to the left of the fireplace Fawkes's small version of 'The Sun Rising through Vapour' (Butlin and Joll, 1984, no.95) and to the right 'The Victory Returning from Trafalgar', 1806 (Butlin and Joll, 1984, no.59). The drawing-room at Farnley leads directly into the library, as can be seen in Turner's pencil study in the small *Farnley* sketchbook (cat.no.14 and ill.2), probably used on the same visit as when this drawing was made.

5 *The Dining Room, Farnley Hall* *c*.1818

Bodycolour on buff paper 314 × 428 (12⅜ × 16⅞)
PROV : Walter Fawkes; by descent to present owner
Private Collection (w 591)

The Dining Room is the largest room in the Georgian house at Farnley, and the most elaborately decorated; it reveals the stylistic debt that Carr owed to his mentor Robert Adam, with whom he had collaborated a few miles away at Harewood over twenty-five years before (see Nares, 1954, p.1808). The *grisaille* medallions inset into the plasterwork were painted by the Swiss artist Théodore de Bruyn, assisted by the little-known artist Thomas Taylor (fl. 1792–1811). The plasterwork itself is attributed to Joseph Rose.

6

6 *The Oak Staircase, Farnley Hall* *c*.1818

Bodycolour on buff paper 318 × 411 (12½ × 16 13⁄16)
PROV : Walter Fawkes; by descent to present owner
Private Collection (w 594)

At the same time as commissioning the new wing by Carr, between 1786 and 1792 Walter Fawkes the elder also began to remodel the interior of the Jacobean Wing, in a seventeenth-century style to provide a suitable context for his family's collection of civil war relics (see Nares, 1954, p.1619). The project was completed by his son Walter Fawkes, Turner's patron, who from 1813 removed to the old wing at Farnley various period details from other houses he owned in the area, and then installed the historical relics themselves to form 'a living museum of the Civil War' (Hill, 1980, p.35). In this drawing some of Fawkes's collection of Parliamentarian banners can be seen hanging on the landing.

Further up the staircase hangs a 'Boar at Bay', one of the four paintings by Frans Snyders (1579–1657) which Fawkes is reputed to have bought from the Orleans Collection in 1793 (it has now been demoted to the studio of Paul de Vos); in the late nineteenth century all four were inset into the panelling of the oak dining-room. The subject of a boar being attacked by hounds also features among the many panels painted by George Walker (1781–1856) in the oak drawing-room in the old wing in *c*.1821 (see also under cat.no.31).

7 *The Banks of the Washburn, with Otley Chevin in the Distance* *c*.1818

Watercolour and bodycolour on buff paper
331 × 409 (13 1⁄16 × 16⅛)
PROV : Walter Fawkes; by descent to Rev. W. Fawkes; his sale, Christie 2 July 1937 (48), bt Leggatt; Dr Rosamund Harding; J.D. Harding Trust.
Private Collection (w 626)

Based on a pencil drawing in the *Hastings* sketchbook (TB CXXXIX) in use *c*.1815–16, this watercolour shows the view looking south from the Washburn Valley near Leathley across Wharfedale to Caley Park beyond (Hill, 1988, ill.7).

8 *Gates at the West Entrance to Caley Park, Otley Chevin* *c*.1818

Bodycolour on grey paper 340 × 434 (13⅜ × 17 1⁄16)
PROV : Walter Fawkes; by descent to W.R. Fawkes, sale Christie 2 July 1937 (51), bt in; MajorLe G.G.W. Horton-Fawkes; bt Bradford 1986
Bradford Art Galleries and Museums (w 611)

Caley Hall was situated on Otley Chevin due South of Farnley Hall and was one of the many houses owned by

Walter Fawkes in the vicinity (it is visible in the foreground of cat.no.2). The park is reputed to have been formed by Fawkes himself and stocked not only with red and fallow deer, but also with zebras, wild hogs and a species of deer from India (*Dictionary of National Biography*, 1908–9, p. 1133). In this watercolour, a small shooting party is entering the park; a few deer are visible on the distant hillside.

9 *Wharfedale from Caley Park* c.1818

Bodycolour on buff paper 327 × 440 (12⅞ × 17 15⁄16)
PROV: Walter Fawkes; by descent to present owner
Private Collection (W 618)

This is one of a number of drawings by Turner in 'the Wharfedale' series which show the panorama looking across the Wharfe Valley from Caley Park (see also under cat.no.2). In the foreground a sportsman is loading his gun, about to take aim at a solitary deer standing on the rocky outcrop in the right-hand middle distance.

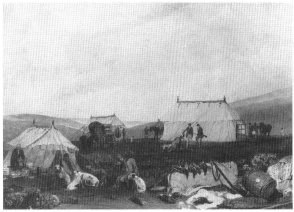

10

10 *Shooting Party on the Moors 12 August* 1816

Watercolour with scratching-out
280 × 397 (11 1⁄16 × 15½)
Inscribed: 'J M W Turner', 'W FAWKES FARN(LEY)', and 'Ale'
PROV: Walter Fawkes; by descent to present owner
Private Collection (W 610)

In the summer of 1816 Turner undertook an extensive tour of Yorkshire in response to a commission to illustrate a publication on the history of the county by the antiquarian author Dr Whitaker. He decided to use Farnley Hall as a base, and deliberately rushed through his tour that year to be back at Farnley in time for the 'glorious twelfth', the episode depicted here. Based on a drawing in the *Large Farnley* sketchbook (TB CXXVIII) of 1816, Turner's water-

colour shows all the equipment of a large shoot – the marquees, the dogs, the guns, the beer barrels and dead game. It would have been on an expedition like this one that he shot the grouse which he subsequently painted for the *Ornithological Collection* (cat.no.31). In the centre foreground a sportsman, thought to be Walter Fawkes himself, holds up a dead blackcock similar to the one also painted by Turner (cat.no.59), and probably intended for the *Collection* as well (see Hill, 1988, p.16).

11 *Fragment of a Letter from Walter Fawkes to Turner* ?1818

'By to-morrow's coach I shall send you a box containing two Pheasants, a brace of partridges, and a hare – which I trust you will receive safe and good. We have tormented the poor animals very much lately and now we must give them a holiday. Remember the Wharfedales – everybody is delighted with your Mill. I sit for a long time before it every day.
Ever very truly yrs.,
W. Fawkes'
TB CLIV Y (Gage, 1980, no.79)
D 12123

Other surviving letters, from Turner to Hawksworth Fawkes (Gage, 1980, nos. 318 and 323), reveal that the artist was often sent parcels of game or foodstuffs from Farnley right up to the year of his death in 1851. The custom perhaps held particular significance for him after the death of Walter Fawkes in 1825, when Turner could not be induced to visit Farnley again.

Fawkes's humane sentiments expressed on behalf of the 'poor animals' which have been 'tormented . . . very much lately' may well have been shared by Turner for in the *Lowther* sketchbook of 1809 (see cat.no.12) the artist wrote a number of poems (one of which has been deciphered by Jack Lindsay, 1966, p.150) in which he appears to express his sympathy for the victims of the shoot. But these poems cannot be interpreted to show that Turner had an 'utmost revulsion from blood-sports' (Lindsay, 1966, p.150), for both Turner and Fawkes clearly enjoyed shooting; Fawkes is prominent in the foreground of 'Shooting Party on the Moors', a gathering which took place in 1816 that Turner was particularly anxious not to miss (see cat.no.10).

This letter is not dated, but Gage's suggestion of c.1818 seems plausible given Fawkes's reference to 'the Wharfedales' (see under cat.no.4). For a discussion of the 'Mill', see Hill, 1980, p.39.

12 *Lowther* sketchbook *c.*1809–10

A Study of Two Pointers
Pencil and watercolour 83 × 114 (3¼ × 4½)
TB CXIII 50 *verso*, 51
D 07930, D 07931

This sketchbook was used by Turner in Cumberland in 1809 when gathering material for a commission from the Earl of Lonsdale for two views of Lowther Castle. However it also contains studies associated with a shoot – figures on the moors, game dogs, and a man seated near an ale barrel holding a gun (Wilkinson, 1974, p.105). Moreover, on some of the pages Turner has written poems on the theme of shooting (see under cat.no.11). It thus seems likely that the *Lowther* sketchbook was reused in the summer of 1810, when Turner made his second visit to Farnley.

13 *Woodcock Shooting* sketchbook *c.*1812

View on the Chevin, with Sportsmen and Beaters
Pencil 110 × 178 (4⁵⁄₁₆ × 7)
TB CXXIX 48
D 09124

A finished watercolour dated 1813 in the Wallace Collection, showing Sir William Pilkington 'Woodcock shooting on the Chiver [Chevin]' (see ill.17), is based on a pencil study in this sketchbook; the scene shown here was clearly drawn on the same occasion. Turner painted a head of a woodcock (cat.no.35) for the *Ornithological Collection*, and a dead woodcock in two still-life studies in the Bequest (cat.nos. 42 and 43).

14 *Farnley* sketchbook *c.*1818

Interior of the Library, Farnley Hall
Pencil, inscribed with colour notes
110 × 185 (4⁵⁄₁₆ × 7⁵⁄₁₆)
TB CLIII 15 *verso*, 16
D 12021, D 12022

In a survey of the paintings at Farnley Hall in 1879, the *Athenaeum* singled out for special praise two seventeenth-century Dutch still-life paintings – 'Dead Game and Fruit' by Jan Weenix (1642–1719) and 'Peacock and other Birds' by his cousin Melchior de Hondecoeter (1636–1695). There can be little doubt that it is these two pictures which hang either side of the doorway in this study of the library by Turner. For their relative proportions and dimensions, as well as their subject-matter, exactly correspond with the fuller description given in Christie's sale catalogue for 28 June 1890, when they were put on the market by Ayscough Fawkes (grandson of Walter Fawkes): '84. N [*sic*]. Hondikoeter. A Garden Scene, with a peacock and peahen, and other birds, 49 in by 40 in; and 85. J. Weenix. A Garden Scene, with a dead hare suspended from a sculptured vase, a dead turkey, partridge, and fruits, a chateau in the foreground. Signed and dated, 1705. 48 in. by 40 in. From the Orleans Gallery.'

Fawkes is listed as a purchaser of Dutch and Flemish pictures from the Orleans Collection in 1793 by William Buchanan in *Memoirs of Painting* (see F. Herrmann, 1972, p.145). The four paintings by Snyders at Farnley were reputed to have come from the same source (see under cat. no.6). Fawkes's taste for still-life, animal and game subjects helps provide a context for Turner's own still-life studies of game probably also made at Farnley (cat. nos. 42 and 43).

Hanging over the fireplace is Turner's oil of 'Shoeburyness Fisherman Hailing a Whitstable Hoy' (Butlin and Joll, 1984, no.85) bought by Fawkes *c.*1810; on either side, the pelmeted bookshelves would have accommodated Fawkes's growing collection of natural history books, and probably the *Ornithological Collection* as well, although it was almost certainly not bound at this date.
[illustrated page 12]

15 *Ornithological Collection*, volume II *c.*1820–25

Title page: part 2 Land Birds
Morocco-bound album containing 108 interleaved brown and white pages (the latter watermarked 1810) onto which have been pasted feathers, wood engravings by Bewick and watercolours by various artists. Displayed to show page with plumage of the peacock
507 × 350 (20 × 13¾)
Private Collection

As the title page indicates, the second volume of the *Ornithological Collection* was devoted to the second half of volume one of Bewick's *History of British Birds*, ranging from 'Of the Lark' to 'Of the Plover'. The peacock was the fourth bird listed by Bewick under the genus 'Of the Gallinaceous kind' which immediately preceded that 'Of the Plover'. As is customary throughout the album, the bird's feathers are labelled according to which part of the body they come from: 'Head' 'Back' 'Rump' 'Breast' 'Wing Coverts' 'Wing' 'Wing Coverts' and 'Tail' in this example. As one might expect, these are amongst the most colourful and decorative in the *Collection*. Facing the feathers would have been Bewick's wood-engraving of the peacock pasted down onto the *verso* of a brown page, on the opposite side of which would have been Turner's watercolour (cat.no.28). The fact that only a white page is visible to the left-hand side is clear proof that a sheet has been removed at this point.

The section which covered the birds belonging to the genus 'Of the Gallinaceous kind' contains some of the largest and bulkiest feathers in the entire *Collection*, and as

a result it is this volume which has suffered the most; the spine has become damaged and the pages severely buckled. Yet it was also here where, in a section chiefly devoted to game birds, the highest proportion of Turner's watercolours were placed – eight or nine would have followed each other in an almost continuous sequence (see cat. nos. 24–32). It thus seems likely that it was this volume in particular which so aroused Ruskin's concern in 1851 about the likelihood of damage to Turner's watercolours, prompting him to advise their removal.
[illustrated page 19]

TURNER'S BIRD AND GAME STUDIES

16–35

'The Farnley Book of Birds': 20 watercolours painted by Turner *c*.1815–20 for the Farnley Hall five-volume *Ornithological Collection*, from which removed in the mid-nineteenth century and subsequently mounted in an album on 17 sheets; recently remounted separately by Leeds City Art Galleries.
PROV: Walter Fawkes; by descent to Mr and Mrs Nicholas Horton-Fawkes, sale Sotheby 12 July 1984 (58 a–t), purchased the following year by Leeds. Leeds City Art Galleries

16 *Moorhawk* ('Head of Moor Buzzard')

From the *Ornithological Collection*, vol.I; frontispiece to 'Birds of Prey: the Falcon tribe' Watercolour over pencil, with traces of a gilt border to the left and right 107×136 $(4\frac{1}{4} \times 5\frac{3}{8})$

As the frontispiece to 'Birds of Prey: the Falcon tribe' which opened Bewick's *History of British Birds*, Turner's 'Moorhawk' was the first watercolour to appear in the *Ornithological Collection*. Another watercolour of a 'Moor Buzzard', by Samuel Howitt, is included later in the section, and followed in turn by his drawings of a 'Kite' and a 'Sparrow-hawk' (ill.18).

The first five birds listed by Bewick under 'the Falcon tribe' – four eagles and an osprey – were deliberately omitted (ill.6) from the *Ornithological Collection*, presumably because the feathers proved too difficult to obtain (see Appendix I, no.2, letter from Francis Hawksworth to Ayscough Hawksworth).

17 *Barn Owl* ('Head of White Owl')

From the *Ornithological Collection*, vol.I; frontispiece to 'Of the Owl'. Watercolour over pencil 261×195 $(10\frac{5}{16} \times 7\frac{11}{16})$

Since this watercolour served as the frontispiece to 'Of the Owl', rather than appearing in its listed place as the fifth owl of the genus (see ill.6), the double-page spread of wood engraving and bird's feathers has remained intact in the *Ornithological Collection* (see ill.7).
[illustrated page 18]

18 *Jay* ('Jay, dead')

From the *Ornithological Collection*, vol.I; frontispiece to 'Birds of the Pie kind' Watercolour over pencil 190×232 $(7\frac{1}{2} \times 9\frac{1}{8})$ Inscribed: 'I M W T'

The feathers of the jay in the *Ornithological Collection* have preserved their sheen and colour remarkably well (par-

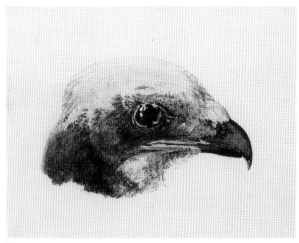

16

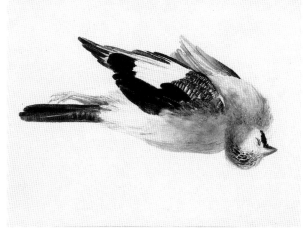

18

ticularly the blues of the wing feather); the page on which they are mounted is, together with that of the peacock's feathers (ill. 8), one of the most decorative in all the volumes.

Turner's 'Jay' was selected as the frontispiece to 'Birds of the Pie kind' in preference to his slighter watercolour of a 'Head of a Cuckoo' (cat.no.19) which appears later in the section, following Howitt's watercolours of a 'Red-legged Crow' and 'Nutcracker'. Feathers for the golden oriole also appear under this genus, immediately after the nutcracker, although the bird does not appear in Bewick's list of contents (see ill. 6).

19 *Cuckoo* ('Head of Cuckoo')

> From the *Ornithological Collection*, vol. I.
> Watercolour over pencil 74×74 ($2\frac{15}{16} \times 2\frac{15}{16}$)
> Inscribed: 'I M W Turner R A' ('MW' in monogram)

In Bewick's *History of British Birds* (vol. I) the cuckoo appears towards the end of the genus 'Birds of the Pie kind' where it is listed, unnumbered, between the redwing and the wryneck (see ill. 6). In the *Ornithological Collection* this watercolour was placed in its listed position, although inserted between two pages of birds' eggs by William Lewin, 'eggs of the pie kind' and 'eggs of the cornish chough, cuckoo, shrike'.

This watercolour may well have been copied from a dead specimen shot by Turner himself, who in 1850 wrote in a letter to Hawksworth Fawkes: 'A Cuckoo was my first achievement in killing on Farnley Moor in ernest request of Major Fawkes to be painted for the Book' (Gage, 1980, no. 323).

20 *Green Woodpecker* ('Head of Green Woodpecker')

> From the *Ornithological Collection*, vol. I; frontispiece to 'The Woodpeckers'
> Watercolour over pencil with scratching-out
> 243×188 ($9\frac{9}{16} \times 7\frac{1}{16}$)

As in the case of the 'Moorhawk' (cat.no.16), Turner's 'Green Woodpecker' (ill. 13) was selected as a frontispiece in preference to Samuel Howitt's version of that bird (ill. 14). Here, however, Turner's watercolour served both as the frontispiece and as the first of the woodpeckers listed by Bewick in the 'Contents of the First Part' (see ill. 6); as a result, Howitt's watercolour was displaced to a position following rather than preceding the page with the bird's feathers. Other watercolours included in this section are a 'Middle-Spotted Woodpecker', also by Howitt, and a 'Dead Treecreeper' by John Ibbetson.
[illustrated page 23]

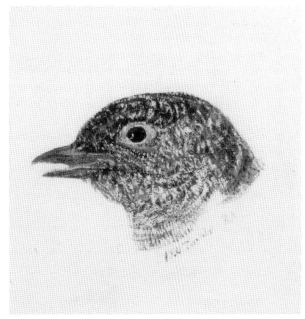

19

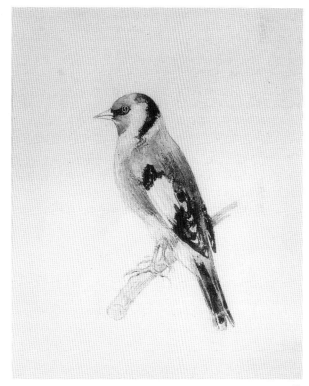

21

21 *Goldfinch* ('Goldfinch')

> From the *Ornithological Collection*, vol. I; probably frontispiece to 'Of the Finch'
> Watercolour over pencil with scratching-out
> 174×145 ($6\frac{7}{8} \times 5\frac{3}{4}$)

Of the twenty watercolours by Turner removed from the *Ornithological Collection*, the 'Goldfinch' is one of the more

difficult to place. However, the evidence strongly suggests that it originally formed the frontispiece to the genus 'of the Finch', a sub-section of the Passerine order (see ill. 6). The position for this frontispiece in volume one is now occupied by a watercolour of a 'Chaffinch' by John Ibbetson, entitled 'Passerine order'; but this has almost certainly been moved here from its original position introducing the 'Passerine' order, for it is the only brown page in the *Collection* to have been hinged onto one of the guards with white tape, rather than being bound into the volume itself. This appears to be the only instance where any attempt was made, by altering the order of the watercolours remaining in the volumes, to compensate for the removal of those by Turner.

22 *Robin* ('Robin redbreast')

From the *Ornithological Collection*, vol. II; frontispiece to 'Of the Warblers'
Watercolour over pencil, traces of an embossed border on the left and right edges, gilt at the left
140 × 177 (5½ × 7)
Inscribed: 'J M W Turner'

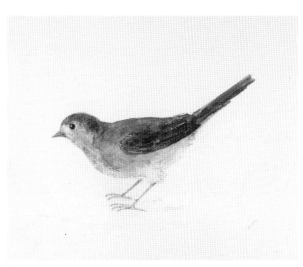

22

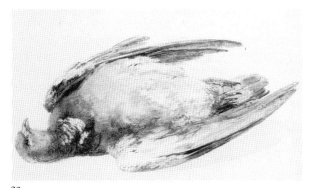

23

In the list of contents for the *History of British Birds* (vol. I), Bewick lists eighteen birds under the genus 'Of the Warblers' (see ill. 6). In the *Ornithological Collection* three of these were illustrated with watercolours; the 'Robin' by Turner, which served as a frontispiece, the 'Nightingale' by Howitt and a 'Dead Wren' by John Ibbetson.

23 *Woodpigeon* ('Ring Dove, dead')

From the *Ornithological Collection*, vol. II; frontispiece to 'Of the Dove kind'
Watercolour over pencil 210 × 285 (8¼ × 11 3/16)

On 10 January 1852 Ruskin wrote to his father: 'You must come some day to visit **Mr. Fawkes** with me, and see Turner's ringdove – a rainbow made of down'. Over the ensuing years it was the ringdove which, perhaps of all Turner's bird drawings, continued to hold the highest place in Ruskin's esteem. Yet Ruskin may well not have been the first to single out this watercolour for special attention. For on the occasion of his visit to Farnley the previous April, when he had first seen the *Ornithological Collection*, the 'Ring Dove' – together with the 'Grouse, hanging' (cat.no. 31) – had already been removed and separately mounted; both watercolours are listed separately on page three of the catalogue of the Farnley Hall Turner's compiled by **Hawksworth Fawkes** in 1850.

24 *Gamecock* ('Head of Game Cock')

From the *Ornithological Collection*, vol.II; probably the frontispiece to 'Of the Gallinaceous kind'
Watercolour over pencil with gum
184 × 221 (7¼ × 8¾)
Inscribed: 'I M W Turner' ('IMW' in monogram)

Only one page has been cut out at the beginning of the genus 'Of the Gallinaceous kind', implying that this watercolour (ill. 28) was both the frontispiece and an illustration to the first bird named in Bewick's list, the domestic cock (see ill. 6). It was immediately followed by an almost continuous sequence of eight or nine watercolours by Turner (cat.nos. 24–32), broken only by that of a 'Blackcock' by Edward Swinburne (see ill. 19).

It has been pointed out by Densley that the gamecock depicted in Turner's watercolour cannot have been a fighting bird as its plumage and wattle have not been trimmed (Hill, 1988, p. 44). Bewick discussed the gamecock under the last of his variations of the 'Domestic Cock', commenting on how 'strikingly beautiful and animated' it appeared when in 'full plumage and not mutilated for the purpose of fighting' (*History of British Birds*, 1805 edn, Vol.I, pp. 289–90).

Domestic fowl roam freely in the foreground of Turner's view of 'The West Lodge, Farnley' *c*.1818 (w 588) and

thus this watercolour, like that of the 'Peacock' (cat.no. 28), may have been painted from the live bird. A cock and chickens also appear in his drawing of a 'Farmyard with Cock' (cat.no. 46) and are seen feeding in the foreground of the oil 'A Country Blacksmith Disputing upon the Price of Iron' (Butlin and Joll, 1984, no. 68) which Turner exhibited at the Royal Academy in 1807 (see ill. 27).
[illustrated page 35]

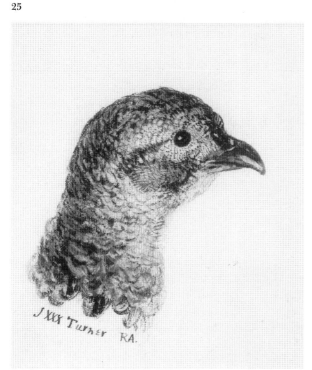

25

26

25 *Pheasant* ('Head of cock pheasant')

From the *Ornithological Collection*, vol. II; probably mounted on same page as 'Head of hen pheasant' (cat.no. 26)
Watercolour over pencil with scratching-out
113×112 ($4\frac{7}{16} \times 4\frac{3}{8}$)
Inscribed: (possibly not by Turner) 'J M W Turner R A' ('MW' in monogram)

This watercolour and 'Head of hen pheasant' (cat.no. 26) were presumably pasted down on the same sheet, since only one page has been removed at this point in the volume; and given that Hawksworth Fawkes lists the cock pheasant before the hen in his catalogue of the Farnley Hall Turners (1850), this watercolour was probably on the upper half of the page. This is the only occasion in the *Ornithological Collection* where watercolours were provided for both the male and female of a species.

26 *Pheasant* ('Head of hen pheasant')

From the *Ornithological Collection*, vol. II; probably mounted on the same page as 'Head of cock pheasant' (cat.no. 25)
Watercolour over pencil, with scratching-out, traces of an embossed border at the left and right edges
116×100 ($4\frac{9}{16} \times 3\frac{15}{16}$)
Inscribed: (possibly not by Turner) 'J M W Turner R A' ('MW' in monogram)

See cat.no. 25.

27 *Turkey* ('Head of Turkey Cock')

From the *Ornithological Collection*, vol. II
Watercolour over pencil 123×124 ($4\frac{13}{16} \times 4\frac{7}{8}$)
Inscribed: 'J M W Turner R A' ('MW' in monogram)

In Bewick's day turkeys were bred 'in great numbers in Norfolk, Suffolk and other counties, whence they are driven to the London markets in flocks of several hundreds. The drivers manage them with great facility, by means of a bit of red rag tied to a long rod, which, from the antipathy these birds bear to that colour, effectually drives them foward' (*History of British Birds*, 1805 edn, vol. I, p. 299). The turkey is listed by Bewick between the pheasant and the peacock under the genus 'Of the Gallinaceous kind'.

Studies of turkeys by Turner also appear in both the *Swans* and the *Salisbury* sketchbooks (cat.nos. 48 and 49).
[illustrated page 43]

28 *Peacock* ('Head of Peacock')

From the *Ornithological Collection*, vol. II
Watercolour over pencil with scratching-out
326 × 244 (12⅞ × 9⅝), and with a preliminary pencil
sketch of a peacock's head on the reverse
Inscribed: 'I M W Turner'

A 'Peacock's Head' and 'Grous' (see cat.no.31) are both
listed under drawings by 'I.M.W.Turner, Esq. R.A.P.P.'
in the earlier of two catalogues published in 1819 for the
exhibition held by Walter Fawkes at his London house,
45 Grosvenor Place that year. This was probably the only
occasion during Turner's lifetime that any of his bird
drawings were seen in a public exhibition. Since the water-
colours are listed separately in the catalogue (as items nos.
23 and 34 respectively), they cannot yet have been bound
into the *Ornithological Collection*.

Densley has suggested that this watercolour may have
been made from the live bird in the grounds of Farnley Hall
(Hill, 1988, p.50).
[illustrated page 19]

29 *Guinea Fowl* ('Head of Guinea Fowl')

From the *Ornithological Collection*, vol. II
Watercolour over pencil 97 × 102 (3¹³⁄₁₆ × 4)
Inscribed: 'I M W Turner R A' ('MW' in monogram)

The guinea fowl is listed in the index to volume two of the
Ornithological Collection under Bewick's title, 'Pintado', the
fifth bird in the genus 'Of the Gallinaceous kind'. For
another head of a guinea fowl by Turner, facing the other
direction, see cat.no.61.

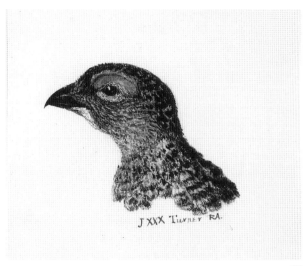

30

30 *Head of a Grouse* ('Head of Grouse')

From the *Ornithological Collection*, vol. II
Watercolour over pencil, traces of an embossed
border at the left and right edges
96 × 113 (3¹³⁄₁₆ × 4½)
Inscribed: (possibly not by Turner) 'J M W Turner
R A' ('MW' in monogram)

When the watercolours by Turner from the *Ornithological
Collection* were mounted in a separate album some time in
the second half of the nineteenth century, this watercolour
was entitled 'the Moorgame'.

31 *Red Grouse* ('Grouse – hanging – killed by the Artist')

?From the *Ornithological Collection*, vol. II
Watercolour over pencil, with bodycolour and gum
262 × 207 (10¹⁵⁄₁₆ × 8³⁄₁₆)
Inscribed: 'I M W Turner R A P P' ('MW' in
monogram)

Like the 'Woodpigeon' (cat.no.23), this watercolour is
listed separately (as item 25 on page 3) in the catalogue of
the Farnley Hall Turners drawn up by Hawksworth
Fawkes in 1850. Fawkes surmised that it had originally been
placed immediately after the 'Head of a Grouse' (cat.no.30),
but only one page has been cut out here and this must
account for the 'Head of a Grouse' itself. Nor could the
'Grouse – hanging' have been a frontispiece to the genus
'Of the Gallinaceous kind' if one assumes that this function
was already being served by the 'Gamecock' (see cat.no.24).
It thus seems possible that this watercolour, even if intended

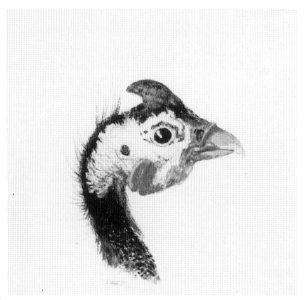

29

for the *Ornithological Collection*, may never in the end have been pasted into the appropriate volume.

It is almost certainly this watercolour which was exhibited at Walter Fawkes's house in London in 1819 under the title 'Grous' (see also cat.no. 28). Soon afterwards it was copied by George Walker in oil on one of the many panels of sporting subjects he painted in the oak drawing-room at Farnley Hall *c.* 1821.

At some stage Turner made a replica of the subject for Fawkes's niece, Amelia Hawksworth (cat.no. 63), presumably as a pair to the 'Dead Blackcock' (cat.no. 59). A variant is cat.no. 60, which was owned and inscribed by Ruskin. [illustrated page 32]

32 *Partridge* ('Head of Partridge')

> From the *Ornithological Collection*, vol. II
> Watercolour over pencil, traces of an embossed
> border at the left edge 91 × 100 (3⅝ × 4)
> Inscribed: (possibly not by Turner) 'J M W Turner
> R A' ('MW' in monogram)

Although followed by four other species listed by Bewick under the genus 'Of the Gallinaceous kind' – the Quail, Corncrake, Great Bustard and Little Bustard – the partridge was the last bird in this section of the *Ornithological Collection* to be illustrated with a watercolour.

32

33 *Kingfisher* ('Kingfisher, dead')

> From the *Ornithological Collection*, vol. III
> Watercolour over pencil with scratching-out
> 178 × 164 (7 × 6 7/16)
> Inscribed: 'I M W Turner R A' ('MW' in
> monogram)

Most of Turner's bird drawings appear to have been worked up in watercolour over pencil in front of the dead (or in some cases live) specimens, rather than being elaborated from preliminary studies made in sketchbooks. The exception is the 'Kingfisher', for which there exists a slight outline study in the *Devonshire Rivers, No. 3, and Wharfedale* sketchbook (cat.no. 50), dateable to *c.* 1815. This is the only direct clue which can help date the Farnley bird drawings, other than the stylistic evidence provided by the watercolours themselves.

The 'Kingfisher' was greatly admired by Ruskin who, on his second visit to Farnley Hall in 1884, is recorded as having examined it 'for a long time with a microscope, and he said he could not find words to describe its exquisite beauty' (Edith Mary Fawkes, 1900, p. 622). Ruskin himself made an equally detailed watercolour study of a kingfisher (cat.no. 57). A kingfisher is seen perched on a boulder in Turner's watercolour, 'A Rocky Pool' (cat.no. 47, ill. 29). [illustrated page 31]

34 *Heron* ('Head of Heron')

> From the *Ornithological Collection*, vol. III; frontispiece
> to 'Of the Heron'
> Watercolour over pencil with scratching-out
> 250 × 292 (9 13/16 × 11 7/8)

Turner's bird drawings are remarkable for their originality and freshness of vision, differing dramatically from the more conventional representations of professional eighteenth-century bird illustrators – even from the more naturalistic designs of Thomas Bewick. However, in depicting the 'Heron' with a fish in its beak Turner may well have been inspired by Bewick's wood-engraving – which would have been pasted onto the *verso* of Turner's watercolour – showing the heron similarly about to devour an eel.

Nevertheless, Turner was clearly familiar with the species and its habitat from direct experience; his watercolour of 'A Rocky Pool' (cat.no. 47, ill. 29) shows a heron in flight, whilst that of a view 'On the Washburn, Under Folly Hall' of *c.* 1815 (w 538) depicts the bird prominently perching on a rock in the foreground.

This watercolour served both as the frontispiece to the genus 'Of the Heron' and as the first of the birds listed by Bewick in that section; it is followed a few pages later by a watercolour of a 'Head of a Bittern' by Edward Swinburne. [illustrated page 37]

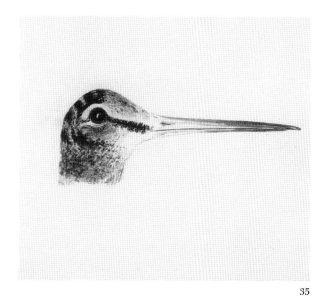

35 *Woodcock* ('Head of Woodcock')

> From the *Ornithological Collection*, vol.III; frontispiece
> to 'Of the Snipe'
> Watercolour over pencil, traces of an embossed
> border at the left edge 140 × 169 (5 $\frac{9}{16}$ × 6 $\frac{11}{16}$)

In Hawksworth Fawkes's 1850 catalogue of the Farnley Hall Turners, the woodcock is given as number 18 in the list of the artist's twenty 'watercolour drawings of Birds from Nature'. But this is clearly a mistake; for the woodcock followed rather than preceded the kingfisher and heron both in Bewick's list of contents and in the *Ornithological Collection* itself. This watercolour was thus the last one by Turner to be pasted into the *Collection*.

The woodcock was the first bird listed by Bewick under the genus 'Of the Snipe', but Turner's watercolour almost certainly served as a frontispiece as well. A more elaborate watercolour of a 'Judcock' in a marshy landscape by Edward Swinburne (ill.12) was selected as the opening frontispiece ('Of the Fen Birds') for volume three in preference to Turner's 'Woodcock'.

Bewick records that the woodcock, being a game bird, was 'eagerly sought after by the sportsman' (*History of British Birds*, 1805 edn, vol.II, p.62). It was certainly shot at Farnley, for a finished watercolour by Turner dated 1813 shows Sir William Pilkington – who was a visitor at Farnley Hall – 'Woodcock shooting on the Chiver' (that is, Otley Chevin) (ill.17); a related episode is recorded by Turner in the *Woodcock Shooting* sketchbook (see cat.no.13). In addition, a dead woodcock is shown hanging beside a dead pheasant in the two unfinished still-life studies of game in the Turner Bequest (cat.nos. 42 and 43), probably drawn at Farnley.

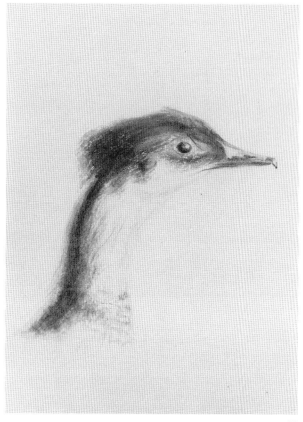

36 *Head of a Red-breasted Merganser c.1815–20*

> Watercolour over pencil
> 166 × 147 sight size (6 $\frac{9}{16}$ × 5 $\frac{13}{16}$)
> PROV: Amelia Hawksworth (Mrs Hotham), ? to
> whom given by the artist; by descent to present
> owner
> Maas Gallery

In 1810 Francis Hawksworth wrote to Thomas Bewick that he had been 'a long Time employed in collecting Feathers of every bird described by you in your two books of Land and water birds' (see Appendix I, no.5). The only section of the *History of British Birds* which was not in the end covered in the *Ornithological Collection* (with the exception of the four eagles and osprey at the very beginning of the 'Land Birds') was the second third of 'Water Birds' ranging from 'Of the Phalarope' to 'Of the Mergus'. This section would have provided enough material for a whole volume, which would have been bound up as number IV in the *Collection*. There seems little doubt that this watercolour and that of the smew (cat.no.37) were intended for this volume where they would have appeared as numbers 3 and 4 of the genus 'Of the Mergus'. The volume was presumably abandoned at quite a late stage when the feathers proved too difficult to come by.

This head, which shows the female of the species, was

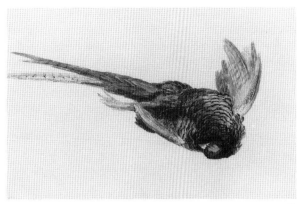

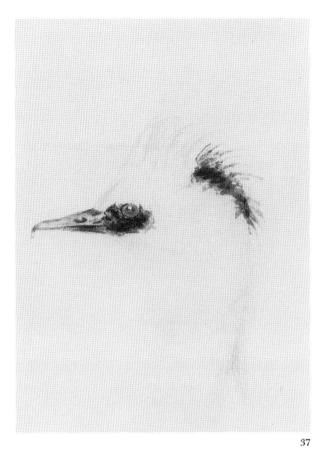

probably drawn from a dead specimen shot at Farnley during the winter months. Writing in 1821, Graves records that 'during the winter this species resorts to many of the Northern parts of Great Britain, but is rarely met with in the South' (*British Ornithology*, 1811–21, vol.III).

37 *Head of a Smew c.1815–20*

Watercolour over pencil
170 × 150 sight size (6$\frac{11}{16}$ × 5$\frac{7}{8}$)
PROV: Amelia Hawksworth (Mrs Hotham), ?to whom given by the artist; by descent to present owner
Maas Gallery

In 1821 Graves wrote that the smew was 'the most abundant of the Mergus family that resort to Great Britain, frequenting extensive lakes and rivers during the winter, usually in small flocks of from four to six birds' (*British Ornithology*, 1811–21, vol.III). The specimen shown in Turner's watercolour may well have appeared on Lake Tiny in Farnley Park, or the lake at Gosforth in Northumberland, the home of Francis Hawksworth's brother-in-law, Charles Brandling, who helped to collect feathers for the *Ornithological Collection*.

Like the 'Head of a Red-breasted Merganser' (cat.no. 36),

this watercolour was almost certainly intended for the *Collection*. It shows the handsome drake smew, which thanks to its characteristic black and white plumage, was known to early wildfowlers as 'the White Nun'. Nowadays the bird is more commonly found as a winter visitor in the South-east of England.

38 *Sketch of a Pheasant c.1815–20*

Watercolour over pencil with scraping-out
223 × 345 (8$\frac{3}{4}$ × 13$\frac{5}{8}$)
PROV: ?Walter Fawkes; John Ruskin, by whom given to the Ruskin Drawing School, Oxford, 1875; transferred to the museum, 1938
REPR: in colour, Herrmann, 1986, fig.76
Visitors of the Ashmolean Museum, Oxford; Ruskin School Collection (Herrmann, 1964, no.78; w 634, reproducing cat.no. 40 in error)

This watercolour could just, by a few millimetres, have fitted onto one of the pages of the *Ornithological Collection*. However it is one of a number of finished watercolours by Turner of dead game (see also cat.nos. 39–40, 59–60, and 63) which, although probably made at Farnley, seem never to have been intended for the *Collection* itself. Rather they were probably made for members of the Fawkes family to keep, especially those most closely involved in the project; for example, Amelia, daughter of Francis Hawksworth who had been chiefly responsible for collecting the feathers, owned two game studies by Turner (cat.nos. 59 and 63) as well as three studies of bird's heads (cat.nos. 36, 37 and 61).

In addition to this watercolour, Ruskin managed to acquire four other bird studies by Turner of dead game (cat.nos. ?39, 40, 60 and 65). Herrmann speculates that the 'Sketch of a Pheasant' may have been given to Ruskin on his first visit to Farnley in 1851 as a present from Hawksworth Fawkes, Walter Fawkes's eldest son, but adds that this would not account for the others he owned (Herrmann, 1964, p.96). In any case, assuming that Turner's bird studies outside the *Collection* itself were owned by different mem-

bers of the family, many would have left Farnley by the mid-nineteenth century. Perhaps some of them were included in the sale of 'a Collection in the West of England' in 1868 from which Ruskin bought two subjects from 'the Wharfedales' series (see under cat.no.4), and which Hill suggests might have been the collection of one of Fawkes's seven daughters (Hill, 1980, p.44).

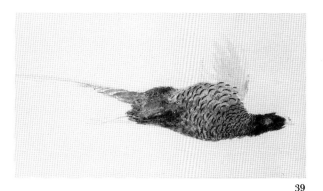

39

39 *Study of a Dead Pheasant c.1815–20*

Watercolour over pencil 191 × 335 (7½ × 13¼)
PROV: ?Walter Fawkes; ?John Ruskin, sale Christie 15 April 1869 (10), bt Vokins; later acquired by Sir Donald Currie, and by descent to present owner
Mr J. L. F. Fergusson

Two studies of dead pheasants by Turner were included in the Ruskin sale at Christie's on 15 April 1869, and listed as lot numbers 10 and 11 in the catalogue which Ruskin wrote himself (see Cooke and Wedderburn, 1903–12, XIII, pp. 569–70). 'The Dead Pheasant' in the Whitworth Art Gallery (cat.no.40) can certainly be identified with lot number 11. This little-known watercolour – one of the most broadly handled of all Turner's dead game studies with the exception of the unfinished watercolours in the Bequest (cat.nos. 42 and 43) – may perhaps be identifiable with lot 10, which Ruskin described thus: 'Dead Pheasant. Slight, but a beautiful example of Turner's most rapid work in the middle period'. See also under cat.no.38.

40 *Dead Pheasant c.1815–20*

Watercolour over pencil, with scratching-out
286 × 376 (11⅜ × 14⅞)
PROV: ?Walter Fawkes; John Ruskin, sale Christie 15 April 1869 (11), bt Vokins; by whom sold to Agnew's; J. E. Taylor, by whom presented to the Whitworth Institute, 1892
The Whitworth Art Gallery, University of Manchester (W 635, Hartley 33)

When Ruskin sold this watercolour at Christie's in 1869

(see also cat.no. 39) he described it in the catalogue as 'Dead Pheasant. Finished study. Superb.' It is indeed the most detailed, technically the most elaborate (with much use of finger prints and scratching-out) and also the largest of the three studies of dead pheasants by Turner he owned (see also cat.nos. 38–39). It has been suggested that it has been cut down at the right-hand side, across the pheasant's tail (Hill, 1980, p.52 and Hartley, 1984, p.44). However, even with its present dimensions, this watercolour would have been too large to fit into the *Ornithological Collection* for which, in any case, it was probably not intended (see under cat.no.38).

Ruskin himself made similar studies of dead pheasants, often in watercolour with bodycolour, which are clearly influenced by Turner's: one in the Victoria and Albert Museum (D. 394–1907, ill. Lambourne and Hamilton, 1980, p.331) which is probably the ' "Dead Pheasant" by Ruskin after Turner' exhibited in Manchester in 1904 as no.185 and shown side by side with this watercolour lent by the Whitworth as no.184; and one listed by Hartley as at Clonterbrook (Hartley, 1984, p.45).

'Dead Pheasant' was owned by John Edward Taylor, the son of the founder of *The Manchester Guardian*, who amassed a fine collection of English watercolours in the late nineteenth century many of which, like this one, he donated to the Whitworth Art Gallery. His collection of watercolours by Turner was particularly extensive, and included three other watercolours of birds (cat.nos. 59, 63 and 64), as well as two studies of fish (see Christie, 8 July 1912, nos. 124 and 146).
[illustrated page 38]

41 *Study of Dead Game; a Hare, an Oystercatcher and Two Woodcock c.1815–20*

Watercolour over pencil 205 × 205 (8 × 8)
PROV: ?Mrs Booth; acquired c.1897 by the Rev. W. H. Churchill; by descent to Arnold Churchill; bt by present owners from Fry Gallery, 1985
Private Collection

This watercolour is traditionally believed to have been found towards the end of the nineteenth century in the boarding house on Cold Harbour, Margate, which was run from 1827 until some time in the 1840s by Caroline Sophia Booth, Turner's mistress and companion in his late years. The artist did not meet Mrs Booth until the late 1820s or early 1830s. However this drawing must belong to an earlier period; for it shows many of the stylistic features common to the bird studies Turner made at Farnley c.1815–20, such as the detailed, dry brushwork on the hare's coat, and the dabbing of dark washes on the plumage of the two woodcock.

Nevertheless, the compositional arrangement of the 'Dead

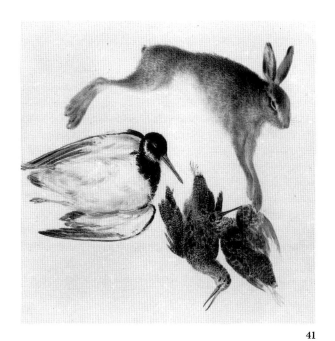

41

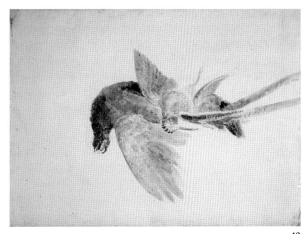

43

Game' (?seen on a table, from above) is distinctly awkward; if it lacks, on the one hand, the simplicity and clarity of presentation evident in, say, Turner's study of dead fish (cat.no.51), so it is also lacking on the other hand in the visual complexity of the groupings he experimented with in his large unfinished still-life studies in the Bequest (cat.nos. 42 and 43). It is included in this exhibition so that, by comparison with the artist's other game and still-life studies, the question of its attribution to Turner can finally be resolved.

42 *Study of a Dead Pheasant and Woodcock Hanging against a Picture Frame* c.1820

Watercolour over pencil 758 × 539 (29$\frac{7}{8}$ × 21$\frac{11}{16}$)
Watermark: 1818
T B CCLXIII 358
D 25481

Perhaps inspired by the studies of dead game he had already made at Farnley, all of which showed a single bird (cat.nos. 31, 38–40, 59–60 and 63), in about 1820 Turner experimented with two, more complex still-life compositions featuring a dead pheasant and a dead woodcock. In this example, the birds are seen hanging against a picture frame (or, perhaps, a mirror); in the other (cat.no.43) the same two birds appear to be leaning on a table ledge which has as yet to be painted in. Walter Fawkes owned a number of Dutch and Flemish seventeenth-century still-life and animal paintings, including two oils by Weenix of dead game (Christie, 28 June 1890, nos. 85–86; see also under cat.no.14). It thus seems possible that these two studies by Turner could be related to a commission from Fawkes for a large watercolour of a still-life subject which the artist never completed.

43 *Study of a Dead Pheasant and Woodcock* c.1820

Watercolour over pencil 542 × 749 (21$\frac{3}{8}$ × 29$\frac{9}{16}$)
Watermark: 1818
T B CCLXIII 359
D 25482

Like catalogue number 42, this watercolour is only half-finished. It is a good example of how most of Turner's bird drawings would have looked at this intermediate stage before the addition of dry brushwork and scratching-out to create surface texture – although the artist has already applied a large thumbprint near the pheasant's tail.

Unlike Turner's other studies of birds and fish in the Bequest, Ruskin does not appear to have selected this one or cat.no.42 for exhibition at the National Gallery in the second half of the nineteenth century, probably because they are so noticeably unfinished.

44 *Study of a Teal with Outspread Wings* c.1820

Watercolour over pencil 312 × 467 (12$\frac{7}{16}$ × 18$\frac{7}{16}$)
T B CCLXIII 340
D 25463

In some of Turner's early sketchbooks there are a number of studies of birds in flight, and of birds rising from or alighting onto a stretch of water (cat.nos. 48–49). Yet most of his finished watercolours either show dead specimens, or concentrate on the head and neck of the bird only. 'Study of a Teal with Outspread Wings' and 'Study of a Teal Flying' (cat.no.45) are unique amongst such finished works in showing a bird in movement.

This watercolour is too large to have fitted into the *Ornithological Collection*, but may well have been painted at Farnley. The teal probably frequented Lake Tiny in the grounds at Farnley Hall, where Turner himself appears to

have gone bird watching; the *Farnley* sketchbook (see cat. no. 14) is inscribed on the first page 'Ducks 2. 1 Mallard – nothing else stirring', and is immediately followed by a pencil study of the lake. Moreover, volumes four and five of the *Collection* both contain specimens of the teal's feathers, as well as three watercolours of the bird itself (by Chevalier de Barde, Lady Armytage and an unattributed hand, see Appendix II).

[illustrated page 40]

45 *Study of a Teal Flying* c.1820

Watercolour over pencil 274 × 438 (10$\frac{13}{16}$ × 17$\frac{1}{4}$)
TB CCLXIII 341
D 25464

When Ruskin exhibited this watercolour at Marlborough House in 1857–58 in the first of the selections he made from the Turner Bequest, he singled it out in the accompanying catalogue for particular praise; together with the 'Study of a Teal with Outspread Wings' (cat. no. 44), and the 'Ring-dove' at Farnley which he regarded as superior (see cat. no. 23), 'these bird drawings of Turner [are] more utterly inimitable than, so far as I know, anything else he had done'. In addition 'to the wonderful drawing and colour' Ruskin also admired 'the peculiar execution by which the spotted brown plumage is expressed'. This watercolour, and cat. no. 44, are indeed remarkable examples of the very skilful and effective way in which Turner manages to capture the light and furry texture of the body feathers by manipulating a dry brush.

Ruskin's own drawings of ducks are, like his studies of pheasants (see under cat. no. 40), clearly inspired by Turner's example. In the study of 'A Dead Wild Duck' in the British Museum (1901–5–16–1), for example, he also succeeds in capturing the soft texture of the bird's plumage, though essentially through the use of bodycolour which Turner himself only rarely and sparingly used in his bird drawings. Ruskin's diary reveals that he was working on several bird drawings in January 1867, to which year both the duck study and his version of 'A Dead Pheasant' in the Victoria and Albert Museum are usually dated (Arts Council, 1964, p. 24).

[illustrated page 39]

46 *Farmyard with Cock* c.1808

Pen and ink over brown and pink washes
183 × 260 (7$\frac{1}{4}$ × 10$\frac{3}{8}$)
TB CXVI T
D 08121

Between 1807 and 1819 Turner made a number of careful monochrome drawings like this one for the *Liber Studiorum*, a series of prints in which he hoped to demonstrate his range of skills as a landscape artist. For this purpose he divided up landscape painting into a number of different branches– 'Historical, Mountainous, Pastoral, Marine and Architectural', together with 'Epic [or Elevated] Pastoral'. 'Farmyard with Cock' was engraved in 1809 by the artist's namesake, Charles Turner, under 'Pastoral', the category chiefly devoted to subjects of rustic genre.

Just as in many of his genre paintings of this period Turner pays tribute to seventeenth-century Dutch sources (e.g. Butlin and Joll, 1984, nos. 68 and 209), so too in this drawing the artist may have had in mind the farmyard scenes of artists like Melchior de Hondecoeter (1636–1695) and Paulus Potter (1625–1654). Moreover, about the time this drawing was made, c.1808, Turner made his first visit to Farnley and would have seen Fawkes's fine collection of Dutch and Flemish oils, chiefly purchased in the 1790s; these included two paintings of 'Domestic Poultry', one by Paulus Potter (Christie, 28 June, 1890, lot 80, signed, 20$\frac{1}{2}$ × 28″) and one by Aelbert Cuyp (*idem*, lot 82, signed, 23$\frac{1}{4}$ × 28$\frac{1}{2}$″).

47 *A Rocky Pool, with Heron and Kingfisher* c.1815

Watercolour with scratching-out
309 × 400 (12$\frac{1}{8}$ × 15$\frac{3}{4}$)
PROV: John Knowles, sale Christie 5 June 1880 (485, as Wharfedale, Richmondshire), bt Fine Art Society; J. E. Taylor, sale Christie 5 July 1912 (49, as 'A Lonely Dell near Wharfedale'), bt Agnew; C. E. Fairfax-Murray; Asa Lingard; Fine Art Society, from whom purchased by Leeds, 1957
Leeds City Art Galleries

Despite Finberg's suggestion (1909, p. 158) that this watercolour relates to a study of rocks in the 'Scottish Pencils' series, most recent authors have tended to favour its traditional identification as a view in Wharfedale. Indeed it is sometimes still referred to by its old title, 'A Lonely Dell, Wharfedale' (Hill, 1988, p. 6), apparently acquired when it was in the collection of John Edward Taylor, who also owned a number of Turner's bird drawings (see under cat. no. 40). Certainly 'A Rocky Pool' is stylistically close to other Wharfedale watercolours made for Sir William Pil-

48

49

kington in about 1815 (e.g. w 536, 'Mowbray Lodge' and w 538, 'On the Washburn, under Folly Hall' which also includes a heron), and is thus likely to share a similar date. Turner's watercolours of a 'Heron' (cat.no.34, ill.30) and of a 'Kingfisher' (cat.no.33, ill.22) from the Farnley Hall *Ornithological Collection* also belong to this period. [illustrated page 36]

48 *Swans* sketchbook 1798–99

Study of a Swan Rising from or Alighting onto Water; Study of Two Swans
Pencil, watercolour and white bodycolour; each page measuring 125 × 174 (4⅞ × 6⅞)
T B XLII 14, 15
D 01689, D 01690

Both of these studies have faded badly from exposure. In 1857 they were removed from the sketchbook and framed together as item 122 (N.G.609) of the exhibition which Ruskin selected for Marlborough House, when they were described in the catalogue as 'fine beyond all expression' (Cook and Wedderburn, 1903–12, XIII, p.275). The study of two swans was discussed at greater length by Ruskin in *Lectures on Landscape*, when he compared it with an anonymous engraving of a swan from a Dutch book of academical instruction in Rubens's time; whilst Turner, through truthfulness of perception and rapidity of execution had succeeded in capturing the grace of the bird, the anonymous engraver had laboriously tried to engrave every feather – with the result that his swan resembled a 'leg of pork' (Cook and Wedderburn, 1903–12, XXII, pp. 45–46).

The *Salisbury* sketchbook (see cat.no.49) also contains four sketches of a swan in black chalk.

49 *Salisbury* sketchbook 1799

Sketch of Three Flights of Geese
Pencil, pen and brown ink 121 × 150 (5⅞ × 4⅞)
T B XLIX 1
D 02243

This leaf, together with the next three consecutive pages also showing groups of birds (see Finberg, 1909, p.125), were detached by Ruskin from this sketchbook for exhibition at Marlborough House in 1857; they were listed in the catalogue with two studies from the *Swans* sketchbook (cat. no.48; see Cooke and Wedderburn, 1903–12, XIII, p.275).

50 *Devonshire Rivers, No. 3, and Wharfedale* sketchbook *c*.1815

Sketch of a Dead Kingfisher
Pencil 178 × 252 (7 × 9¹⁵⁄₁₆)
T B CXXXIV 1
D 09789

First used in Devon in 1813, this sketchbook was then taken by Turner to Farnley, probably on his visit in 1815. As well as this slight sketch, on which the finished watercolour in the *Ornithological Collection* was based (see under cat.no. 33), it also contains studies of Bolton Abbey and Fountains Abbey, of Farnley Hall itself and people picnicking in the countryside nearby, and a detailed panorama of Leeds. The inscriptions above the sketch of a dead kingfisher are the endorsements of the executors who first drew up an inventory of the Bequest: '[schedule] no. 223. 75 pencil sketches. H.S. Trimmer, C. Turner'; the pencilled initials 'CLE' and 'JPK' are the two assessors. Sir Charles Lock Eastlake and John Prescott Knight, President and Secretary of the Royal Academy respectively.

51 *Study of Fish: Two Tench, a Trout and a Perch* c.1822

Watercolour over pencil 275×469 ($10\frac{13}{16} \times 18\frac{1}{2}$)
T B CCLXIII 339
D 25462

With its careful handling and detailed finish, this still-life study of freshwater fish has more in common with the artist's bird drawings of c.1815–20 than with his later, more broadly-handled watercolours of marine fish, chiefly mackerel, which are usually dated 1835–40 (see w 1399–1404). It shares certain stylistic affinities with the two studies of teal in the Turner Bequest (cat.nos. 44 and 45), as well as being drawn on a similarly large sheet, and is thus likely to date from about the same time. Ruskin admired the way in which Turner had captured the 'subdued iridescences of the fish' (Cooke and Wedderburn, 1903–12, XIII, p.370).

Turner is known to have spent much time fishing at Petworth, the Sussex seat of his patron, the third Earl of Egremont, whether in the company of the history painter, George Jones (1786–1869) or in friendly rivalry with the sculptor Francis Chantrey (1781–1841) (Cooke and Wedderburn, 1903–12, XXXV, pp.571–72). However it was not until 1827, the year in which Turner renewed contact with his old patron after many years, that these extended visits to Petworth began. Rather, this watercolour seems to have been made by Turner a few years earlier perhaps, like the studies of teal, at Farnley where the artist would have had every opportunity to indulge his passion for angling. Walter Fawkes commissioned a number of watercolours of fish from the artist Samuel Howitt to illustrate his *Synopsis of Natural History*, including one inscribed 'fresh water fish' which is not dissimilar from Turner's study though it is on a much smaller scale (ill.4).

It has been suggested recently (Gage, 1987, p.163) that Turner's own study of four fish may have been intended for a publication on British fish planned by Sir John Fleming Leicester of Tabley Hall where, in 1808, Turner is recorded as having spent much time angling; this, however, seems unlikely in view of its large size.
[illustrated page 40]

52 *Study of a Dead Tench* c.1822-

Watercolour over pencil 234×451 ($9\frac{1}{8} \times 17\frac{11}{16}$)
Watermark: 'J. Whatman, Turkey Mill, 1821'
T B CCLXIII 338
D 25461

Since this study corresponds fairly closely with the dead tench which appears in the upper left-hand corner of the still-life of four dead fish also in the Bequest (see cat.no.51), it can be assumed that it is a preliminary study for that watercolour which was abandoned at an early stage.

53 *Near Blair Athol, Scotland* c.1808

Pen and ink over brown wash
184×264 ($7\frac{5}{16} \times 10\frac{7}{16}$)
T B CXVII G
D 08134

F. E. Trimmer, the son of Turner's old friend the Reverend Henry Trimmer, vicar of Heston, recorded that the artist 'threw a fly in first-rate style and it bespeaks the sportsman whenever the rod is introduced into his pictures' (Thornbury, 1862, I, p.169). Since many of Turner's fishing expeditions were undertaken in the company of friends or fellow artists, there are a number of anecdotes which testify to his skill as an angler. For example the painter George Jones (see under cat.no.51) commented that Turner's 'success as an angler was great, although with the worst tackle in the world. Every fish he caught he showed to me, and appealed to me to decide whether the size justified him to keep it for the table, or to return it to the river' (Thornbury, II, p.123). Turner's fishing rod, presently on loan to the Clore Gallery from the Royal Academy, was acquired on his death by Mrs Booth.

This drawing was engraved by William Say in 1811 for Turner's *Liber Studiorum* (see under cat.no.46) and published under the category 'marine'. Turner's fisherman, here seen wearing breeches, in the print has donned a kilt.

54 *Fishing at the Weir* sketchbook c.1830–35

Man Seated, Fishing at a Weir
Pencil 78×101 ($3\frac{1}{8} \times 3\frac{5}{16}$)
T B CCLXXXI 19 *verso*, 20
D 27760, D 27761

As well as being a successful angler, Turner was also, by all accounts, an extremely patient one, perservering in all weathers. Thornbury tells of an occasion, recounted to him by F. E. Trimmer (see under cat.no.53), when Turner was fishing on 'a raging wet dreary day' in Brentford: 'with one hand he held his huge umbrella, and with the other his rod . . . there he sat all day till the dinner-bell rang, immovable, implacable . . . yet steady, silent, and untiring' (1862, vol.II, p.134).

'Man Seated, Fishing at a Weir' is one of a number of such studies in this sketchbook, the location of which has not been identified.

BIRD DRAWINGS BY OTHER ARTISTS

CHARLES COLLINS (d.1744)

55 *A Sparrowhawk* 1739

Bodycolour 540 × 375 (21¼ × 14¾)
Inscribed: 'Chas. Collins 1739'
Private Collection

Charles Collins is one of the most important and best-known of the professional ornithological draughtsmen working in Britain in the eighteenth century. Most of his drawings are, like this one, in bodycolour, the conventional medium favoured by professional bird artists in this period for its effectiveness in rendering the texture and detail of plumage. By comparison with the rather stiff and formal bird portraits of some of his contemporaries (e.g. George Edwards, 1694–1773) Collins's drawings seem remarkably sensitively and freely painted. Nevertheless he usually follows the eighteenth-century formula of showing the bird in a rather meagre and artificial setting; if not walking on a generalised piece of earth, or swimming on a stretch of water, the bird was almost invariably perched on a branch. Another artist who worked on a similarly large scale as Collins was Peter Paillou (fl. 1745–1780), who made bird drawings for Thomas Pennant's *British Zoology*, 1766.

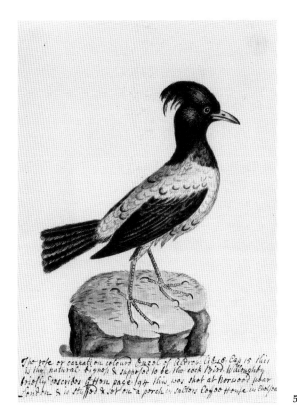

56

SAMUEL NORTHCOTE SENIOR (1708/9–1791)

56 *The Rose or Carnation Coloured Ouzel*

Watercolour over pencil 220 × 175 (8¾ × 6⅞)
Inscribed: 'The rose or carnation coloured Ouzel of Aldrov: Lib: 16. Cap. 15 this is the natural bigness & supposed to be the cock Bird. Willughby briefly describes ye Hen page 94 this was shot at Norwood near London & is stuffed & set on a perch in salters coffee House in Chelsea'.
David Blayney Brown Esq.

Samuel Northcote Senior, father of the portrait painter James Northcote R.A. (1746–1831) was, like many members of this old Plymouth family, a watchmaker by profession. He was also an enthusiastic amateur ornithologist, and made a number of watercolours of birds for his own interest, often inscribing them with references as to where they could be found in the important ornithological literature of the day. In this example he refers to 'ye Hen' ouzel as being listed in Willughby and Ray's *Ornithology* (1678), a publication which has been described as 'the first real attempt to provide a large number of bird illustrations for identification purposes in Britain' (Jackson, 1985, p.57). His reference to the sixteenth-century Italian ornithologist Ulisse Aldrovandi is similarly taken straight from Willughby. Like Northcote, Walter Fawkes was a keen amateur ornithologist, similarly interested in the principles of bird classification; he too owned a copy of Willughby and Ray's *Ornithology*, given to him as a present by his father.

The inscription states that the bird was copied from a stuffed specimen in a coffee house in Chelsea. Although in this period some birds were kept alive in aviaries or cages, the majority were killed, stuffed and set up in conventional poses by taxidermists (Jackson, p.28). This often explains why most eighteenth-century bird drawings look so lifeless and so similar to each other; indeed artists might often be working from the same specimen.

JOHN RUSKIN (1819–1900)

57 *Study of a Kingfisher*

Watercolour and bodycolour 260 × 220 (10¼ × 8⅝)
Visitors of the Ashmolean Museum, Oxford (Ruskin School Collection, R.201)

Ruskin particularly admired Turner's watercolour of a dead kingfisher from the *Ornithological Collection* both on his first visit to Farnley in 1851 and on his second visit in 1884 when he examined it for a long time with a magnifying glass (see under cat.no.33). Ruskin's own 'Study of a Kingfisher' is as detailed as Turner's, but this is achieved by different means. Whilst Turner relies on a dry brush and

the removal of colour by scratching-out to create the texture of the bird's plumage, Ruskin rather resorts to adding local touches of brighter colour (often bodycolour) on the final layer of the plumage to emphasise its highlights.

JOHN RUSKIN

58 *Feathers of the Kingfisher's Wing and Head, Enlarged with, below, a Group of the Wing Feathers Real Size*

Watercolour and bodycolour 377 × 250 (14¾ × 9⅞)
Visitors of the Ashmolean Museum, Oxford (Ruskin School Collection, R.204)

Ruskin's approach to bird drawing was much more analytical than Turner's. As well as making a number of studies like this one, showing individual feathers and their relative sizes, he also made studies of the parts of a bird's plumage, especially the wing feathers. In *The Laws of Fésole* he entered into a lengthy discussion of the 'elementary organic structure' of a bird, explaining the different textures of a bird's plumage as well as the nomenclature of the different parts of a feather: 'A feather always consists of the quill and its rays; a ray of the shaft and its barbs. Flexible shafts are filaments; and flexible barbs, cilia' (Cooke and Wedderburn, 1903–12, xv, pp. 404–5).

Ruskin's pupil, Miss Elizabeth Emily Murray (b. 1847) also made watercolour studies of enlarged feathers and of bird's wings, examples of which are in the British Museum.

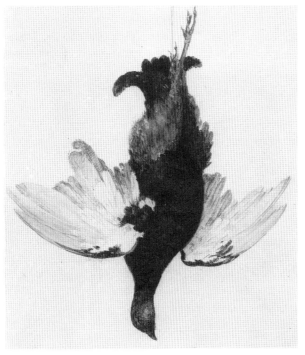

59

BIRD DRAWINGS BY TURNER NOT EXHIBITED

59 *A Dead Blackcock* c.1815–20

Watercolour and bodycolour over pencil, on paper washed in pinkish-grey 258 × 231 (10¼ × 9¼)
Inscribed: 'I M W Turner R A' ('MW' in monogram)
PROV: Amelia Hawksworth (Mrs Hotham), ?to whom given by the artist; J. E. Taylor, sale Christie 8 July 1912 (122), bt Brown & Phillips; R. W. Lloyd, by whom bequeathed to the museum
REPR: in colour, Gage, 1987, fig. 240
Trustees of the British Museum (W 632)

'A Dead Blackcock' is very close in its size, signature and handling to the study of a dead 'Red Grouse' in the Farnley *Ornithological Collection* (cat.no. 31), and like that watercolour may have been intended for the album. In the event, it was given away to Amelia Hawksworth, Walter Fawkes's niece, apparently by the artist himself, and the position in the album was filled by a watercolour of a 'Blackcock' by Edward Swinburne (ill. 19). The 'Red Grouse' remained at Farnley, although it may never in the end have been pasted into the *Collection* (see under cat.no. 31).

Indeed, it is possible that the two watercolours may originally have been painted as a pair. They would certainly have hung well together as complementary still-life subjects. Moreover, Turner painted an identical version of the Farnley red grouse for Amelia Hawksworth (it is described as a 'replica' by Finberg, see cat.no. 63), almost certainly as a pair to this watercolour. In 1857 the two drawings were listed together as the property of Captain Hotham (whom Amelia had married in 1844) in the provisional catalogue to the Art Treasures Exhibition in Manchester. They were later acquired as a pair by John Edward Taylor, who lent them both to an exhibition at the Guildhall in 1899 (London Corporation Art Gallery, Loan Collection). They were separated in 1912 when Taylor's collection was sold at Christie's, and listed in the catalogue together with other bird and fish studies by Turner which Taylor owned, including a 'Head of a Blackcock' (cat.no. 64).

60 *Study of a Dead Grouse* c.1815–20

Watercolour over pencil 235 × 311 (9¼ × 12¼)
Inscribed: lower right-hand margin by Ruskin, 'By J. M. W. Turner / Certified. John Ruskin, Brant.d / 24th July 1886'
PROV: ?Walter Fawkes; John Ruskin; Major E. A. Mackay, sale Sotheby 14 February 1962 (89), bt

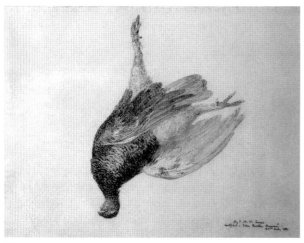

60

Pantzer, and given to the museum in memory of Dr and Mrs Hugo O. Pantzer by their children.
LIT: *J. M. W. Turner: works on paper from American Collections*, Berkeley, California, 1975, p. 86
Indianapolis Museum of Art (w 633)

Wilton has confused this watercolour, which was owned by Ruskin, with the replica of the dead 'Red Grouse' in the *Ornithological Collection* which was given by Turner to Amelia Hawksworth and subsequently owned by John Edward Taylor (cat.no. 63). The Taylor version, being identical to the 'Red Grouse' (cat.no. 31), was also upright in format and similarly signed 'J. M. W. Turner, R.A.' (Christie, 8 July 1912, no. 123); this watercolour, by contrast, is horizontal, bears no signature by Turner but is rather inscribed and authenticated by Ruskin.

Although now badly faded from exposure, this version probably always lacked the spontaneity of the original by which it was inspired (cat.no. 31). There is much pencil visible in the wing area which, rather than lying under the wash as is characteristic of Turner's other bird drawings, is here applied on the surface in a much rougher fashion. It thus seems likely that this is the 'Grouse' which Ruskin exhibited as item 103 in an exhibition of his drawings by Turner at the Fine Art Society in 1878, and which he described in the accompanying catalogue as 'Hard Study, too laboured' (Cooke and Wedderburn, 1903–12, XIII, p. 469).

61 *Head of a Guinea Fowl* c.1815–20

> Watercolour over pencil
> 130 × 118 sight size (5⅛ × 4⅝)
> PROV: Amelia Hawksworth (Mrs Hotham), ?to whom given by the artist; by descent to present owner
> Maas Gallery

Since this watercolour duplicates a subject included in the *Ornithological Collection* (cat.no. 29), it seems likely that it was painted by Turner as an extra version for Amelia Hawksworth (see also under cat.no. 38).

62 *Lid of a Snuff-box*

> *Partridge, Grouse and Gun*
> Watercolour on cardboard, circular, 76 mm (3 in.) in diameter
> LIT: Armstrong, 1902, p. 27; Finberg, 1912, p. 27, no. 171; and Leeds City Art Gallery, *Turner Watercolours from Farnley Hall*, 1948, no. 38
> Private Collection

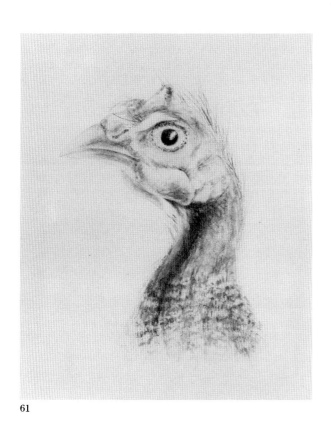

61

63 *Study of a Dead Grouse*

> Watercolour 260 × 222 (10¼ × 8¾)
> Inscribed: 'J. M. W. Turner, R.A.'
> PROV: Amelia Hawksworth (Mrs Hotham), ?to whom given by the artist; J. E. Taylor, sale Christie 8 July 1912 (123), bt Agnew on behalf of Viscount Lascelles to whom sold in same year

Listed as a 'replica' of the 'Dead Grouse, hanging' from the *Ornithological Collection* (cat. no. 31) by Finberg in his catalogue of *Turner's Water-Colours at Farnley Hall*, 1912 (no. 141, p. 27), and identified by him as the watercolour from the Taylor Collection sold in the same year (Christie, 8 July 1912, no. 123). See also under cat. nos. 59 and 60.

64 *Head of a Blackcock*

> Watercolour 133 × 121 (5¼ × 4¾)
> Inscribed: 'J. M. W. Turner, R.A.'
> PROV: J. E. Taylor, sale Christie 8 July 1912 (147), bt Agnew on behalf of Viscount Lascelles to whom sold in same year

65 *Pheasants*

Owned by Ruskin, and exhibited as no. 104 at Fine Arts Society in 1878 when described by him as 'Pheasants. Rapid note of colour for a bit in foreground; splendid'. (Cooke and Wedderburn, 1903–12, XIII, p. 469).

66 *Jay*

Owned by Ruskin and exhibited as no. 105 at Fine Arts Society in 1878 when described by him as 'A Jay. The most wonderful piece of water-colour work at speed I have. It was given me by Mr. W. Kingsley, of Kilverton . . .' (Cooke and Wedderburn, 1903–12, XIII, p. 469).

67 *Study of Cuckoo*

> Watercolour, vignette 305 × 381 (12 × 15)
> PROV: Rev. W. Kingsley

Listed by Armstrong (1902, p. 248) and described as a 'vignette drawing of young cuckoo and motherbird. Probably made at Farnley'.

Appendix I

Transcription of Nine Manuscript Letters, between Thomas Bewick and Members of the Fawkes Family: 1809-1822

1 Francis Hawksworth to Thomas Bewick 27 February 1809
 MS. Iain Bain, Esq.

Sir.

I shall be obliged if you will send the best copy you have of a set of your beasts and birds, The same as you have sent to my brother M.ʳ Fawkes of Farnley a short Time ago – I mean a volume of the Beasts & the Two volumes of birds – & the same size – If you have liesure [*sic*] to touch any of the deficiencies in the Prints, I shall be obliged to you, as I am very fond of drawing & etching myself.

Direct Them to Miss Grimston

 Thorp Arch
 N.ʳ Tadcaster
 Yorks.ᵉ

and I have the Honor to be

 Sir
 Your most ob.ᵗ Serv.ᵗ
 F. Hawksworth.

Thorp Arch
27th. Feb.
 1809.

[Inscribed by Bewick: 'F. Hawksworth Esq.ʳ Books sent by Coach on the 30 March 1809']

2 Francis Hawksworth to Thomas Bewick 22 February 1810
 MS. Iain Bain, Esq.

Sir.
 Please to send me by return of the Coach directed to F. Hawksworth Esq^re
 Heath
 n^r. Wakefield
 To the Care of M^r. Brammel
 White Hart
 Wakefield
the large Edition of your Water Birds. M^r Fawkes, Farnley will pay you for the
above –
 Your ob^t. Serv^t
 F. Hawksworth
Feb: 22:
[1810]

[Inscribed by Bewick: 'F. Hawksworth Esq^r Ans.^d 24 Feb^y 1810']

3 Francis Hawksworth to Ayscough Hawksworth
 MS. Iain Bain, Esq.

My dear Ayscough
 The first Time you go with Charles to Newcastle call upon
Bewick & tell him I shall be much obliged to him if he will ⟨*illeg.*⟩ send me
word – in what county or in what particular places or haunts in Yorkshire I shall
be likely to get specimens of the following birds
The Hobby
The Merlin
Little Owl
Great Ashcoloured shrike x x The red backed Shrike is common
Woodchat at Farnley – I got two specimens
Wryneck the other day. I wish Charles
Hopoe would write his Somersets^e friend
Cross-bill a line & say I only want "the
Pied Flycatcher Great Ashcoloured Shrike".
Tawny Bunting [This paragraph is crossed
 through in the original MS]

[70]

I have got specimens of all the other land birds in his book except The Eagles & those which he says have only been seen once or twice in England viz. Roller – Nutcrack[er.] also tell Bewick, that I have tried a long time to find a Grey linnet without any spot of red upon their heads – but I have killed numbers & find Them all Redpoles – Ask Him whether He conceive[s] that They all ⟨*illeg.*⟩ assume the red forehead in Summer –

[11 lines crossed through]

Best love to Charles and Fanny [crossed through]

<div align="right">Ever yrs F.H.</div>

[3 lines crossed through]

[1810]

[Inscribed by Bewick: 'The Rev^d. F Hawksworth Ans^d 4 July 1810']

4 Charles Brandling to Thomas Bewick 22 December 1810
 MS. Iain Bain, Esq.

M^r. Brandling will be obliged to M^r. Bewicke if he will inform him the name of the Bird accompanying this – & return it – M^r B. thinks it the [?Menzel] Coot or the Lough Diver –

 Gosforth House
 Dec^r. 22^d 1810

The Wing must be returned also

5 Francis Hawksworth to Thomas Bewick 23 December 1810
 MS. Pease collection (Barnes 175), Central Library, Newcastle upon Tyne

I have been a long Time employed in collecting the Feathers of every bird described by you in your Two books of Land and water birds. I am in possession of a great many. I am anxious not to insert any feathers in my book without knowing exactly what species it is – You must therefore excuse me for sending once more over to ask your opinion of the bird you pronounced yesterday to be

the Teal – I conceive ⟨*illeg.*⟩ that it differs from the Hen Teal as follows –
1.^st The head & shape of the bill is totally different – the feathers not being
freckled on the head – 2^nd The weight is different – 3^dly The scapulars & beauty
spot on the wing are totally different – The beauty spot in the Hen Teal being a
Greenish blue colour & in this – The greater coverts of the Wings – & The
secondary quills are principally white – primaries black – It must be either the
Red headed Smew or the Lough Diver – You will do me & M.^r Brandling a favor
[*sic*] by giving me a line & returning the bird after having carefully examined it –

> Your obed.^t Serv.^t
> F Hawksworth.

Gosforth house
Sunday
[23 Dec 1810]

6 Thomas Bewick to Francis Hawksworth 24 December 1810
 (draft reply composed on same sheet as letter no. 5)
 MS. Pease collection (Barnes 175), Central Library, Newcastle upon Tyne

As I never have had it in my power to ascertain, from my
own knowledge, whether my authorities are correct or not, I could do no better
in the meantime than give them implicit credit and it remains, perhaps, yet to be
proved satisfactorily to the Naturalist, that this Bird is really the Female Golden
Eye & that can only be known from the actual observation of the Swedish or the
American sportsman, who will be at the pains to ⟨endeavour⟩ to ⟨*illeg.*⟩ the
opportunity of seeing the Male & Female busied in the work of Incubation –
Much in my opinion remains yet to be done to make truth fully appear, respecting
the Females of many of the Duck tribe as well as of some other kinds of water
Birds which go to distant regions to breed. If you will Sir look on page 252 you
will immediately see that this Bird does not belong to the Genus Mergus – If
what I have said be deemed satisfactory & I can in any way oblige you or M.^r
Brandling I shall think myself happy in having had it ? within my power to
do so –

[Inscribed by Bewick: 'M.^r Hawksworth Ans.^d 24 Dec.^r 1810']

7 Francis Hawksworth to Thomas Bewick 24 December 1810
 MS. Iain Bain, Esq.

Sir

In order that you may judge more correctly what species of bird the one is which I sent you yesterday [see letter no. 5] – I send you gummed between two pieces of Pasteboard – the whole wing & scapulars –

I have preserved in the same way the wing &c of the female Teal which is totally different – The bird sent you weighed between 17 & 18 ounces – You say in your description of the Teal – That the male seldom weighs more than 11 ounces & that the female is less –

The bird sent for your inspection was shot by Mr. Brandling's keeper – who saw four of Them – which flew particularly near the water. Pray send back the birds – In looking carefully a second Time over your book I see the bird exactly answers your description of the Duck called /Morillon/ both in weight & length & particularly in the primaries & secondaries –

Let me know if you please & you will oblige
 Your obt Servt
 F. Hawksworth.

Gosforth House
Monday Morng
[24 Dec 1810]

[Inscribed by Bewick: 'Mr. Hawksworth not answrd An Answer by the bearer,
 Mr. Bewick This Parcel and the bird back']

8 Francis Hawksworth to Thomas Bewick 3 January 1811
 MS. Iain Bain, Esq.

Sir,

I send you enclosed 8 Pounds to pay for the Two Sets of Birds & beasts sent to Mr. Fawkes, for whom I beg a receipt by the bearer –

I hope also to receive by the bearer a couple of your Small Sketches for which Mr. Brandling & Mr. Fawkes will be obliged
 F Hawksworth

Gosforth

Jan 3.d 1811.

[Inscribed by Bewick: 'F. Hawkesworth']

Newcastle 10 Jan^y 1822

Mr Fawkes

Sir

On the other side is a list of the Birds which have been done for the supplement & by the names of which you will know how to place them in the valuable works of M^r Pennant & D^r Latham – As I am extremely desirous of seeing everything new, relative to natural history, you have whetted my curiosity exceedingly respecting the works you have been in hands with, in that way – The German work, you name, on European Birds also greatly excites my curiosity & I long for a sight of it – I have carefully abstained giving any opinion of M^r Selby's great work on Birds

I am
Sir
Your most obed^t
Thomas Bewick

[Addr.] Walter Fawkes Esq^r
Farnley Hall
 Yorkshire
Otley

Appendix II

Watercolours remaining in the 'Ornithological Collection'

Probable position of Turner's watercolours given in square brackets with titles used by Hawksworth Fawkes in his catalogue of the Farnley Hall Turners (1850). 'F' indicates frontispiece. All items in watercolour unless otherwise stated.

VOLUME I (18 watercolours, of which 6 by Turner)

[Turner	Head of Moor Buzzard. F]
S. Howitt	Moor Buzzard
S. Howitt	Kite
S. Howitt	Sparrowhawk
[Turner	Head of White Owl. F]
Mr Taylor	Head of a Red-backed Shrike. F
[Turner	Jay, dead. F]
S. Howitt	Red-legged Crow
S. Howitt	Nutcracker
[Turner	Head of Cuckoo]
[Turner	Head of Green Woodpecker. F]
S. Howitt	Green Woodpecker
S. Howitt	Middle-spotted Woodpecker
J. Ibbetson	Dead Treecreeper
S. Howitt	Hoopoe
J. Ibbetson	Chaffinch. F (subsequently removed to later position in album, see under cat. 21)
E. Swinburne	Yellow Bunting. F
[Turner	Goldfinch. ? F]

VOLUME II (19 watercolours, of which 11 by Turner)

S. Howitt	Pied Flycatcher. F
[Turner	Robin redbreast. F]
S. Howitt	Nightingale
J. Ibbetson	Dead Wren
E. Swinburne	Blue Titmouse. F
Sir William Pilkington	Dead Swallow. F
S. Howitt	Chimney Swallow and Martin
S. Howitt	Swift and Sand Martin
[Turner	Ring Dove, dead. F]
[Turner	Head of Game cock. ? F]
[Turner	Head of cock pheasant]
[Turner	Head of hen pheasant]
[Turner	Head of Turkey Cock]
[Turner	Head of Peacock]
[Turner	Head of Guinea Fowl]
E. Swinburne	Blackcock
[Turner	Head of Grouse]
? [Turner	Grouse, hanging]
[Turner	Head of Partridge]

VOLUME III (8 watercolours, of which 3 by Turner)

E. Swinburne	Judcock. F
S. Howitt	Long-legged Plover
J. Ibbetson	Watercrake
Mr Taylor	Dead Water Ouzel
[Turner	Kingfisher, dead]
[Turner	Head of Heron. F]
E. Swinburne	Head of a Bittern
[Turner	Head of Woodcock. F]

VOLUME IV (2 watercolours, 1 drawing)

Miss Frances Fawkes	Head of a Mallard. F
Unattributed	A dead Golden Eye (pencil)
Chevalier de Barde	Teal

VOLUME V (7 watercolours)

Unattributed	Teal. F
Miss I. Middleton	Head of a Mallard
Lady Armytage	Head of a Shoveller
Lady Armytage	Head of a Wigeon
Miss I. Middleton	Head of a Long-tailed Duck
Edward Swinburne	Head of a Garganey
Lady Armytage	Head of a Teal

TOTAL: 55, of which

20 by Turner	2 by Mr Taylor
13 by Howitt	1 by Chevalier de Barde
6 by Swinburne	1 by Miss Frances Fawkes
4 by Ibbetson	1 by Sir William Pilkington
3 by Lady Armytage	2 unidentified
2 by Miss I. Middleton	

Bibliography

All books published in London unless otherwise stated.

Allen, D.E., *The Naturalist in Britain: A Social History*, 1976.

Altick, Richard D., *The Shows of London*, The Belknap Press of Harvard University Press, Cambridge, Mass. and London, 1978.

Anon, 'The Private Collections of England, No. XLVI, Farnley Hall, Otley', *The Athenaeum*, 27 Sept–15 Nov, 1979, pp. 406–8, 439–40, 470–72, 501–3, 600–1, 636–37.

Armstrong, Sir W., *Turner R.A.*, 1902.

Arts Council, *Drawings by John Ruskin*, exhibition catalogue, 1960.

Arts Council, *Ruskin and his Circle*, exhibition catalogue, 1964.

Arts Council, *John Ruskin*, exhibition catalogue, 1983.

Butlin, M. and E. Joll, *The Paintings of J.M.W. Turner*, 2 vols, 1984.

Chislett, R., *Yorkshire Birds*, 1952.

ed. Cooke, E.T. and A. Wedderburn, *The Works of John Ruskin*, 1903–12.

Daniels, S., 'The Implications of Industry: Turner and Leeds'. *Turner Studies*, 1986, vol. 6, no. 1.

Fawkes, E.M., Mr Ruskin at Farnley', *The Nineteenth Century*, April 1900, vol. 47, pp. 617–23.

Fawkes, E.M., 'Turner at Farnley', unpub. typescript in National Gallery, n.d. [after 1890].

Fawkes, F.H., Ms Catalogue of oil-paintings and water-colour drawings and sketches in watercolour in the possession of F.H. Fawkes, of Farnley Hall, 1850 (copy in V & A Museum Library).

Finberg, A.J., *Complete Inventory of the Drawings of the Turner Bequest . . .*, 1909.

Finberg, A.J., *Turner's Water-Colours at Farnley Hall*, The Studio, n.d. [1912].

Finberg, A.J., 'Turner at Farnley', *The Studio*, vol. 55, 1912, pp. 86–96.

Finberg, A.J., *The History of Turner's 'Liber Studiorum'*, 1924.

Finberg, A.J., *The Life of J.M.W. Turner, R.A.*, 2nd edition, 1961.

Foster, J., *Pedigrees of the County Families of Yorkshire*, 2 vols, 1874.

Gage, J., *Collected Correspondence of J.M.W. Turner*, 1980.

Gage, J., *J.M.W. Turner: 'A Wonderful Range of Mind'*, 1987.

Goldyne, Joseph R., *J.M.W. Turner: Works on Paper from American Collections*, exhibition catalogue, University Art Museum, Berkeley, California, 1975.

Hartley, C., *Turner Watercolours in the Whitworth Art Gallery*, Manchester, 1984.

Hayman, P. and P. Burton, *The Birdlife of Britain*, 1976.

Herrmann, F., *The English as Collectors*, 1972.

Herrmann, L., *Ruskin and Turner: a Study of Ruskin as a Collector of Turner, based on his gifts to the University of Oxford: incorporating a Catalogue Raisonné of the Turner Drawings in the Ashmolean Museum*, 1968.

Herrmann, L., *Turner: Paintings, Watercolours, Prints and Drawings*, 2nd edition, 1986.

Hill, D., *Turner in Yorkshire*, exhibition catalogue, York City Art Gallery, 1980.

Hill, D., 'A Newly Discovered Letter by Turner', *Turner Society News*, Winter 1981/2, pp. 2–3.

Hill, D., *In Turner's Footsteps, through the hills and dales of Northern England*, 1984.

Hill, D., *Turner's Birds*, 1988, with ornithological captions by Michael Densley.

Jackson, C., *Bird Etchings: The Illustrators and their Books, 1655–1855*, Cornell University Press, Ithaca and London, 1985.

Lambourne, L. and J. Hamilton, *British Watercolours in the Victoria and Albert Museum*, 1980.

Lindsay, J., *J.M.W. Turner: his Life and Work*, 1966.

Mallalieu, H.L., *The Dictionary of British Watercolour Artists up to 1920*, 2 vols, 1976.

Mather, John R., *The Birds of Yorkshire*, 1986.

Mullens, W.H. and H. Kirke Swan, *A Bibliography of British Ornithology*, 1917.

Nares, G., 'Farnley Hall, Yorkshire – 1', *Country Life*, 20 May 1954, pp. 1618–21; 'Farnley Hall, Yorkshire – II', *Country Life*, 27 May 1954, pp. 1714–17; 'Farnley Hall, Yorkshire – III', *Country Life*, 3 June 1954; 'Furniture at Farnley Hall', 24 June 1954.

Phelps, G., *Squire Waterton*, Wakefield, 1976.

Roscoe, S., *Thomas Bewick: A Bibliography Raisonné*, 1953, reprinted 1973.

Royal Academy, *Turner 1775–1851*, bicentenary exhibition, 1974, catalogue pub. by Tate Gallery.

Snelgrove, D., *British Sporting and Animal Prints*, 1658–1874, Tate Gallery for Yale Center for British Art, 1981.

Thornbury, W., *The Life of J.M.W. Turner R.A.*, 2 vols, 1862.

Wakefield Art Gallery and Museums, *Charles Waterton 1782–1865: Traveller and Naturalist*, exhibition catalogue, Wakefield, 1982.

Walton, Paul H., *The Drawings of John Ruskin*, Oxford 1972.

Warbuton, S., *Turner and Dr. Whitaker*, exhibition catalogue, Towneley Hall Art Gallery and Museums, Burnley, 1982.

Whitworth Art Gallery, *British Watercolours from the John Edward Taylor Collection in the Whitworth Art Gallery*, Manchester, 1973.

Wilkinson, G., *The Sketches of Turner RA, 1802–20: Genius of the Romantic*, 1974.

Williams, I., *Early English Watercolours*, 1952.

Wilton, A., *The Life and Work of J.M.W. Turner*, 1979.

Wilton, A., *Turner in his Time*, 1987.

Witt, Sir John, *William Henry Hunt (1790–1864): Life and Work*, 1982.

Wood, G. Bernard, 'When the Wild Boar plagued England', *Country Life*, 7 May 1964.